Skyhorse Publishing books may be purchased in bulk at special discounts for sales promo-
tion, corporate gifts, fund-raising, or educational purposes. Special editions can also be creat-
ed to specifications. For details, contact the Special Sales Department, Skyhorse Publishing,
307 West 36th Street, 11th Floor, New York, NY 10018 or info@skyhorsepublishing.com.

Skyhorse® and Skyhorse Publishing® are registered trademarks of Skyhorse Publishing, Inc.®,
a Delaware corporation.

Visit our website at www.skyhorsepublishing.com.

10 9 8 7 6 5 4 3 2

Library of Congress Cataloging-in-Publication Data is available on file.

Cover design by Brian Peterson
Cover photos by Murad Osmann

Print ISBN: 978-1-62914-550-1
Ebook ISBN: 978-1-62914-955-4

Printed in China

CONTENTS

Dedicated to all those who are
in love with life

Introduction

This project came to life through the fun, joy, and spontaneity of traveling together. When you are in love, the world becomes a thrilling adventure. You constantly feel like running and jumping off a cliff into a deep ocean of uncharted territory. As you fall above the surface, you move in harmony to the synchronized beat of your hearts. En route, you plunge through a barrage of emotional bullets, as they pierce your mind, body, and soul. As you descend into the water, you realize nothing could have prepared you for that moment; embraced by an amalgam of happiness, shock, fear, and adrenaline ... finished with the lingering satisfaction of sensory overload.

It was in Barcelona, running and jumping, when we captured our first #FollowMeTo.

Since then, we have found ourselves climbing above the skyline, diving to the ocean floor, flying above the birds, charging through forests, and strolling aimlessly in awe of the architectural marvels—iconic and inconspicuous—that make up every city. Our travels have seen countless marble columns and dirt roads, towering skyscrapers and makeshift favelas. Yet, in every city, our greatest inspirations came from people. Wherever we went, strangers became friends. They shared their stories and tales of their ancestors. They cheered with us in excitement and wept with us in sorrow.

Through the lens of a camera, we found that within beauty there is mystery; within diversity there is similarity; and within immorality there is unyielding purity ... in every corner of the world. And so, we invite you to open your hearts and journey through the grandeur this world has to offer ... so come on, and follow me to ...

M & N

EUROPE

TURKEY
ISTANBUL

Süleymaniye Mosque
(tur. Süleymaniye Cami)

We rarely talk about the story behind the clothing featured in each picture, but we in fact chose the costumes carefully. The attire can convey the mood and atmosphere of different places. We bought this hand-made caftan, decorated with pearls and beads, at a flea market in New York City. It had to wait for its moment in the spotlight in Istanbul; a city veiled in the delicate tapestry of history, luxury, and culture–so similar to my caftan.

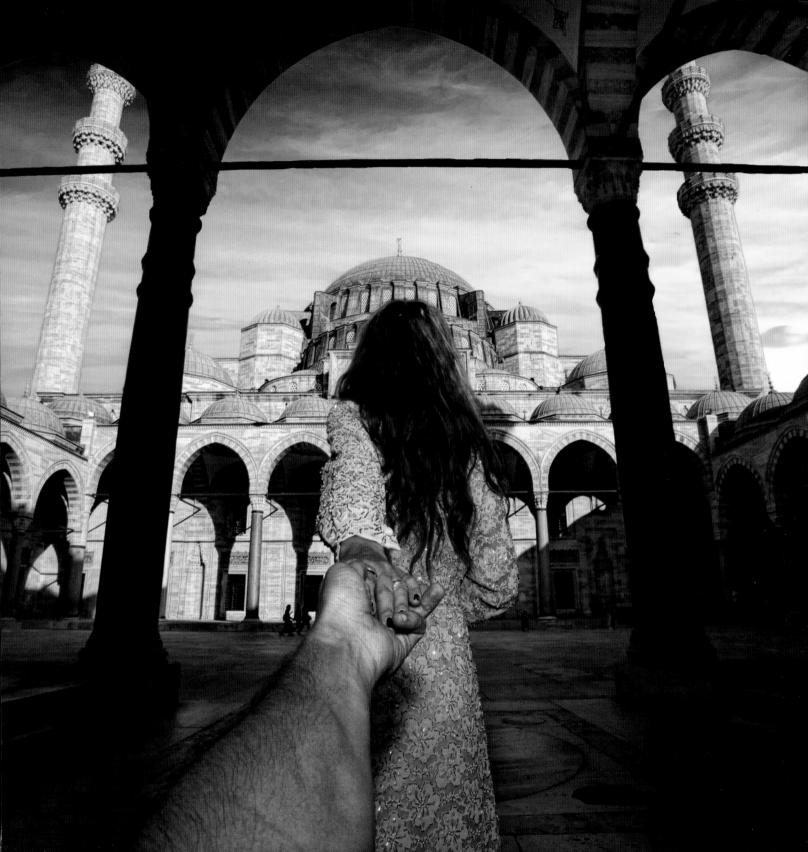

ISTANBUL

Balat District

It is impossible to get to know a country and its people without diving into it's culture, history, and all sides of their social life. We visited the residential areas of Istanbul first. No words can convey it–maybe this photo can.

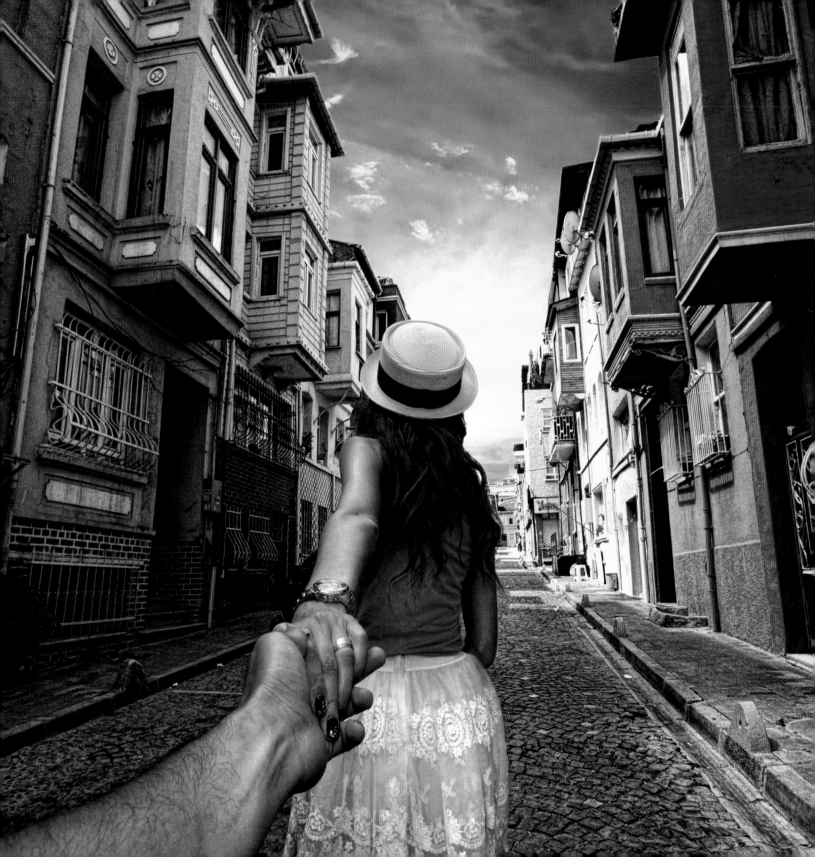

TURKEY
ISTANBUL

Inside the Mosque

We entered the Mosque and raised our heads; it seemed that the whole world was concentrated above us. These places always take your breath away with their grandeur and their cultural, spiritual, and historical heritage.

It was amazing to see how the Mosque and its religious heritage reflects the Turkish nation so vividly.

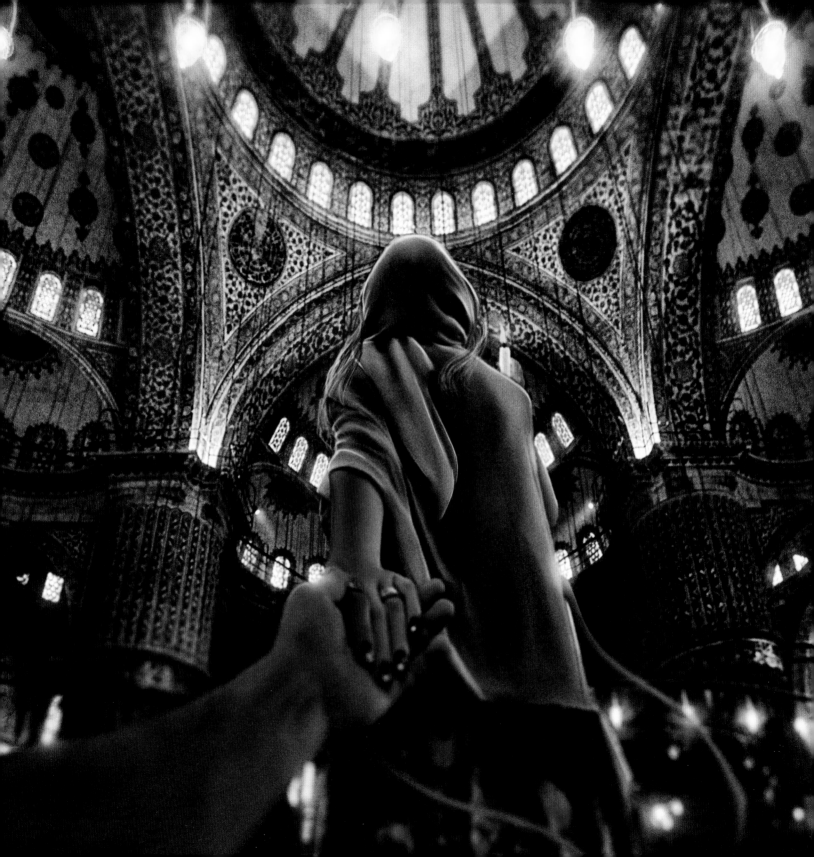

GREAT BRITAIN
LONDON

St. Mary's Hospital

In the summer of 2013, Princess Kate delivered her baby. It was a highly anticipated event that stole the attention of the nation as the press hyped it up. Outside the hospital, we were in the midst of the frenzy. Not long after, the crowd cheered: it's a BOY!

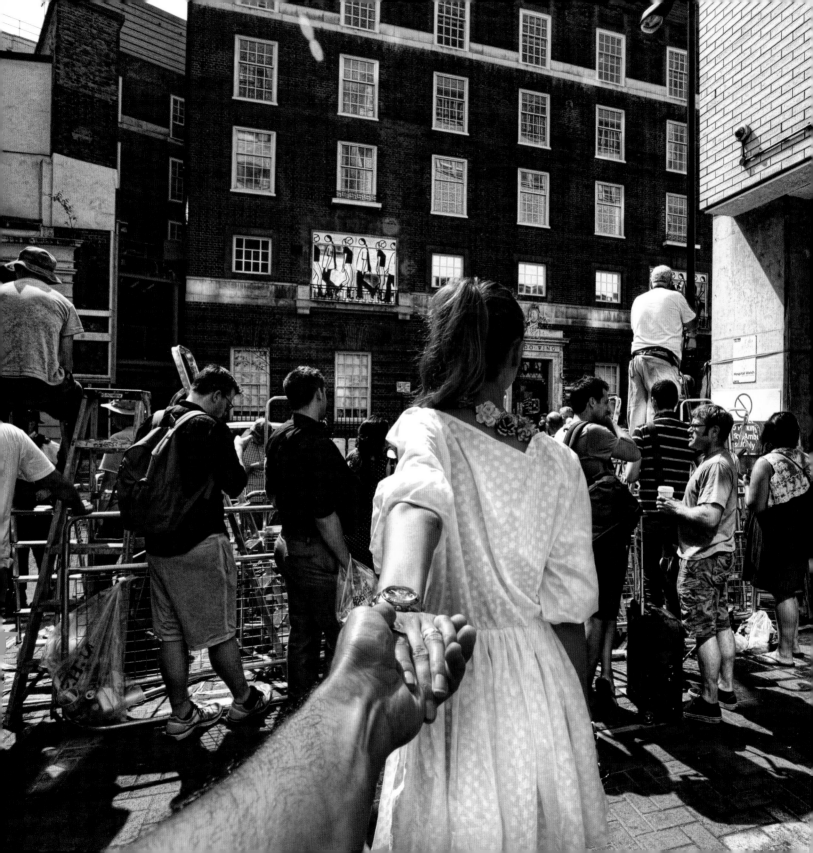

LONDON

Brick Lane

A long street in London with various cafes scattered around. It used to be a Jewish garment district, filled with designers and textile manufacturers. Here, you'll find a spot where they sell the most delicious toast right next to vintage clothing while street artists play classic music in the street. This is another side of London.

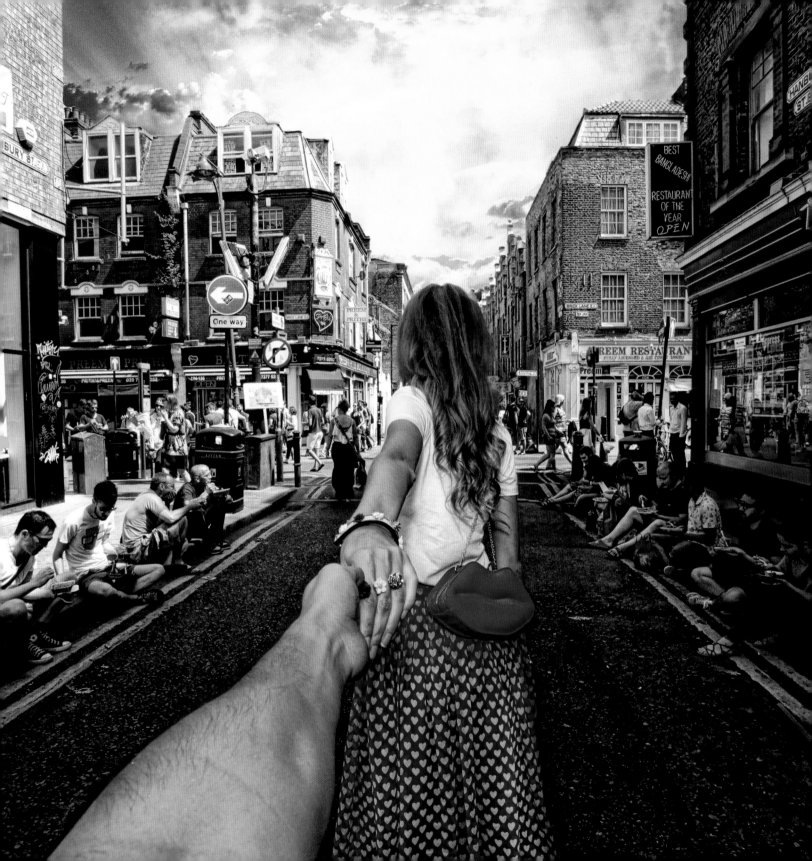

GREAT BRITAIN
LONDON

Piccadilly Circus

Every capital has some central place where people like to gather to talk, drink coffee, and watch other people! Piccadilly Circus is one of those places.

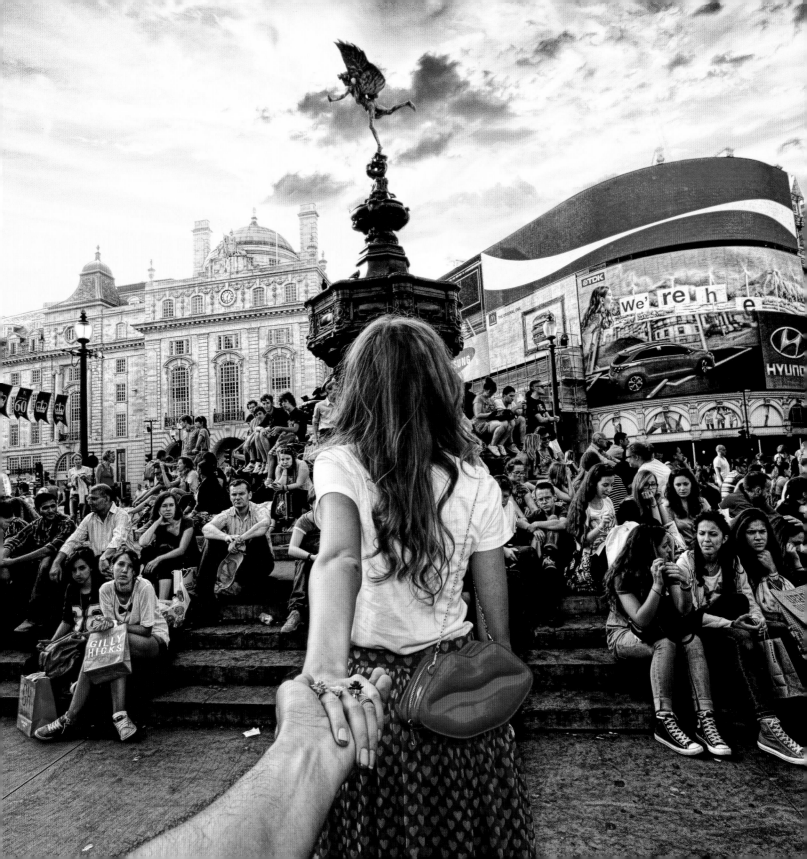

GREAT BRITAIN
LONDON

The Mall

We visited one of London's most iconic streets decorated with hundreds of flags. Sure, you can find the red carpet outside Cannes and Hollywood, but here everyone can sense royalty.

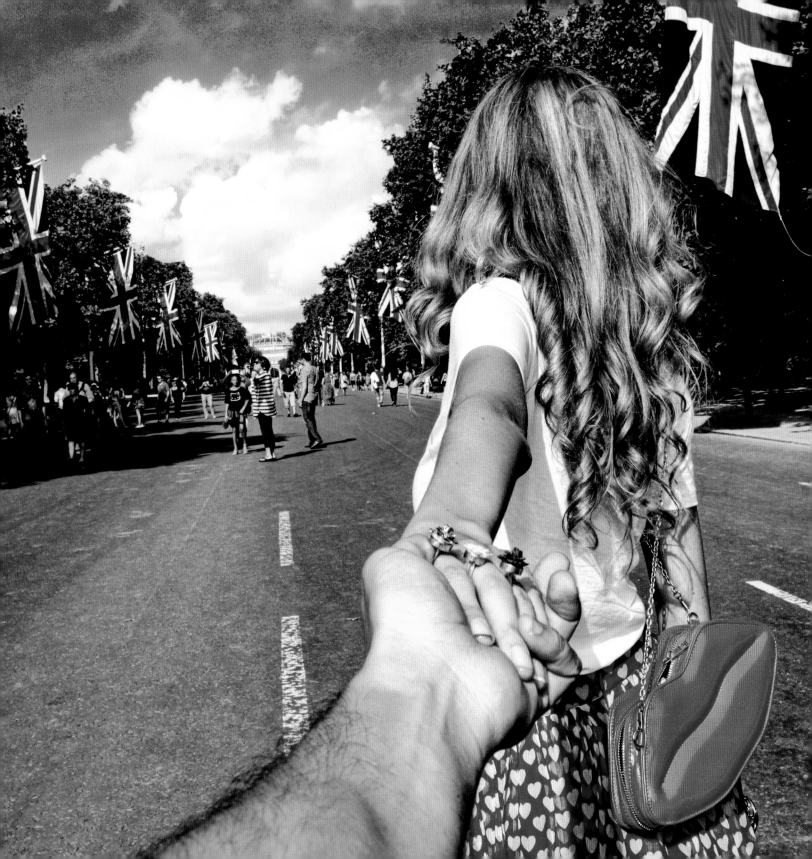

GREAT BRITAIN
LONDON

Big Ben

One of the best-known symbols of England. Such a monumental symbol of British power. There is a Latin phrase along the perimeter of the Tower: "Laus Deo" ("Praise to God").

The Clock Tower used to house a prison where the parliamentarians who misbehaved were sent. The last prisoner to occupy the cell was Emmeline Pankhurst, who fought for women's rights. Today a monument devoted to her stands next to the parliament building.

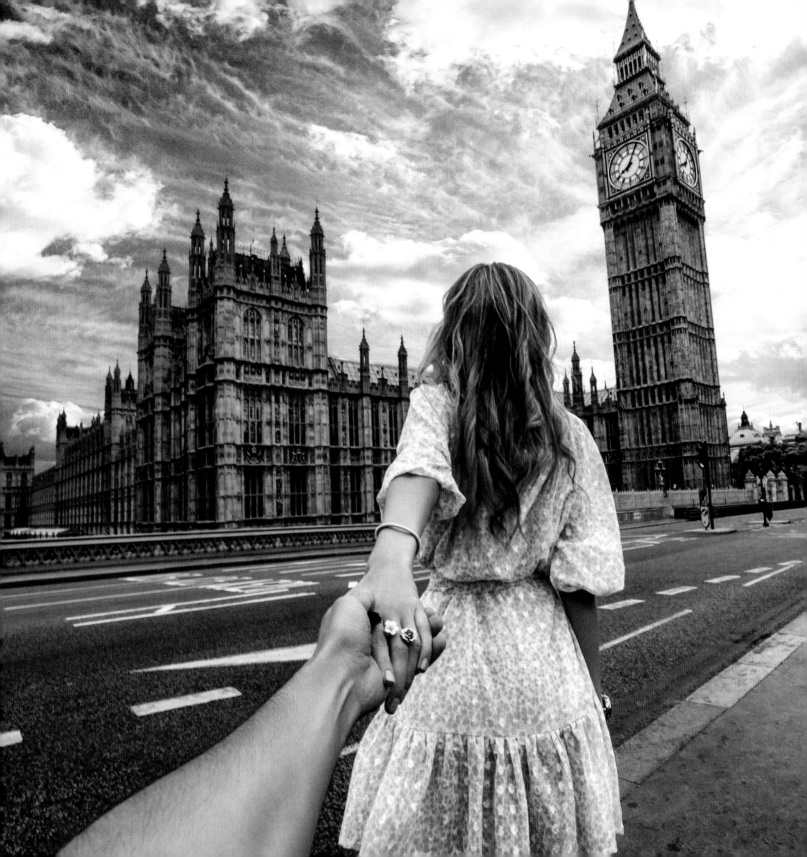

LONDON

Leandro Erlich "Dalston House" Installation

This is an installation by the Argentinian artist Leandro Erlich, a famous innovator in contemporary art and spacial illusions. He built a beautiful Victorian house that lies flat on the ground. He placed a giant mirror over the "house" at a forty-five-degree angle. You can find us in the reflection.

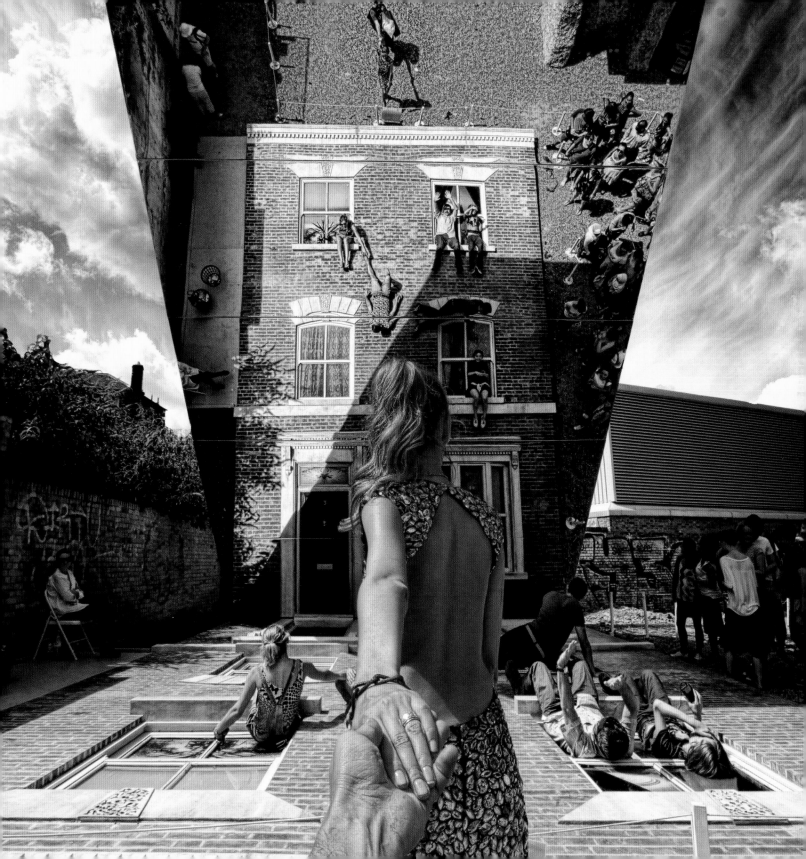

GREAT BRITAIN
LONDON

Harry Potter, Platform 9 ¾

This is the famous Platform 9 ¾, where Harry Potter took the Hogwarts Express. This platform can only be seen and accessed by wizards in the book. Kings Cross is the London destination for Harry Potter fans and magic lovers. We always love being part of a fairytale.

FRANCE
PARIS

The Eiffel Tower

The slimmest, most exquisite, and most recognizable tower that used to be a spot of shame on the skyline of Paris. We had to wake up really early so we could have it all to ourselves in the silence of the Paris morning.

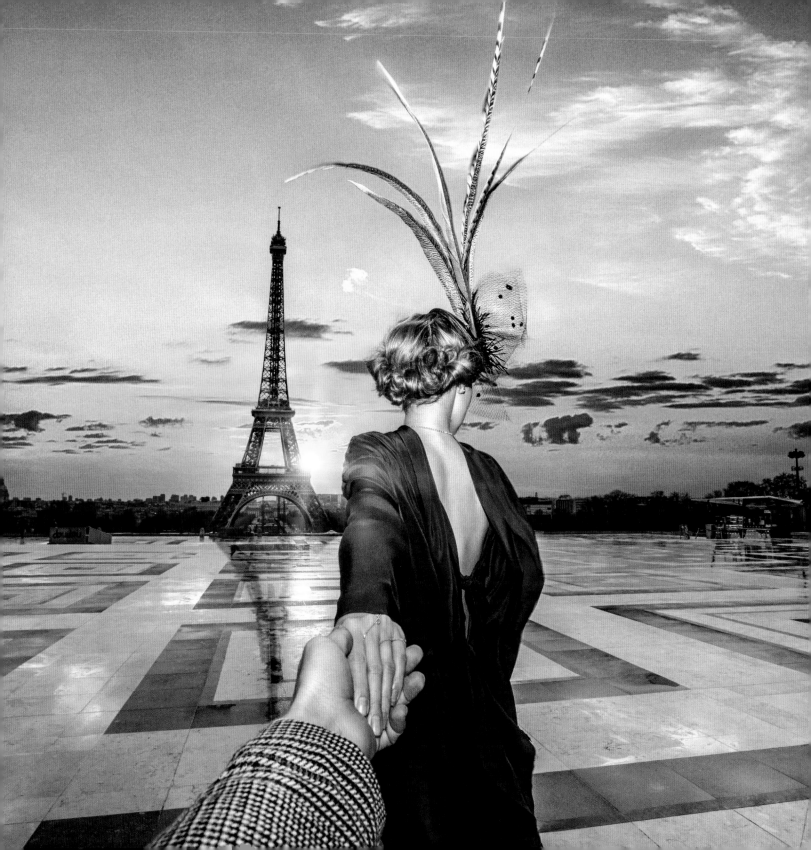

FRANCE
CAP D'ANTIBES

Du Cap-Eden-Roc

Famous for its noble spirit, this legendary place still gathers many celebrity guests. Here, you find yourself wanting to wear a long, flowing dress and imagining yourself as a character in one of Fitzgerald's novels, *Tender Is the Night*.

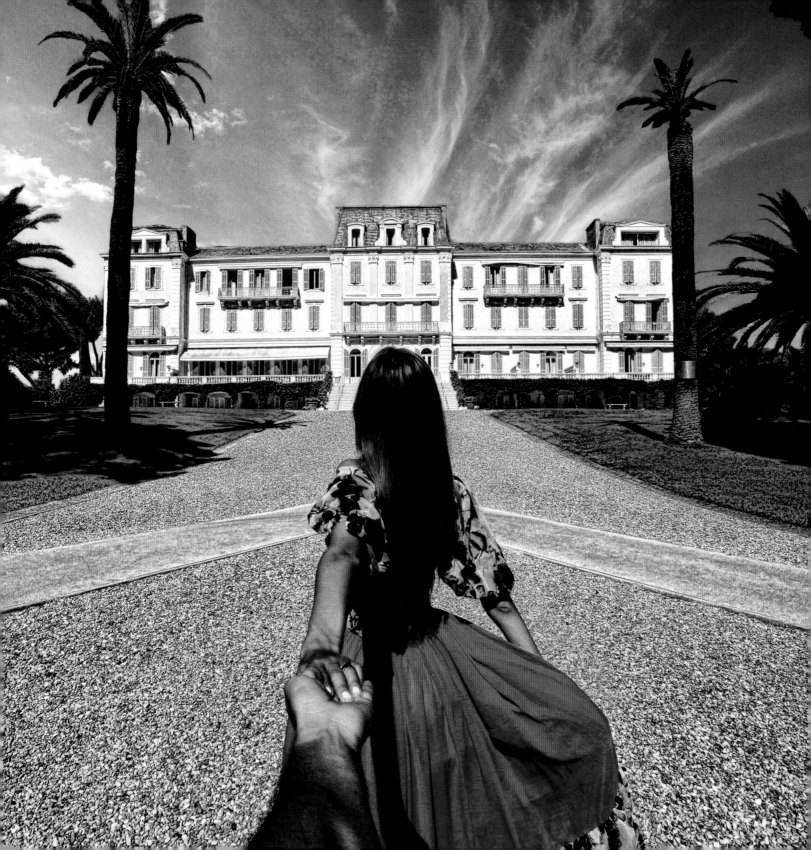

MONTE CARLO

Monaco Port

This city may be heaven for the extremely wealthy, but for us Monaco was just a historical spot of Cote d'-Azur. The total area of this city is only 0.78 square miles (or 2 square kilometers)!

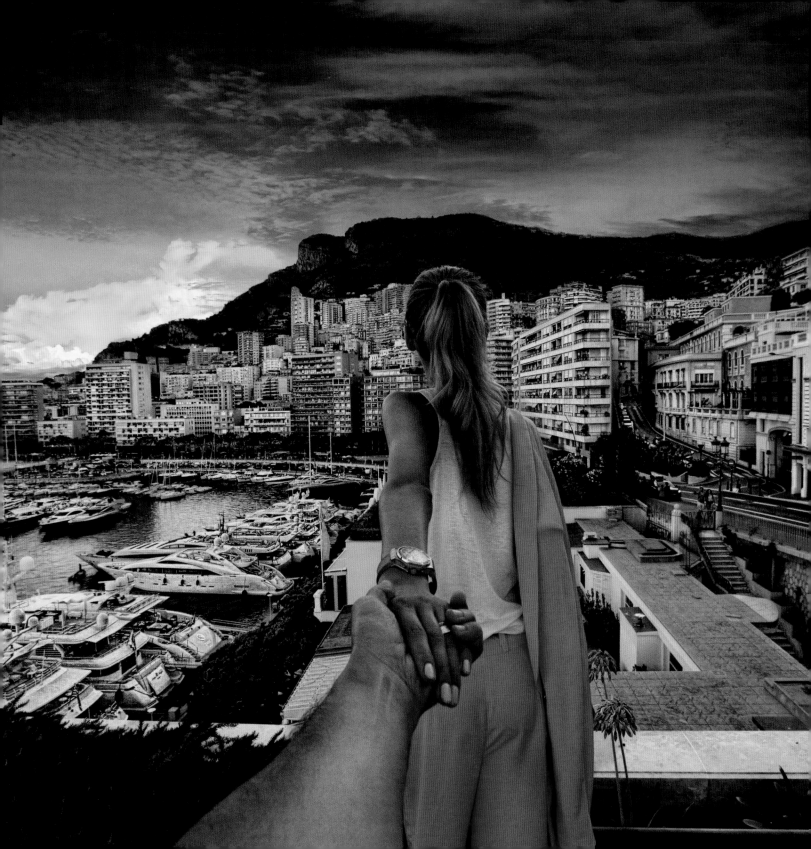

MONTE CARLO

Monaco Casino

One of the most popular spots in Monaco. Every year, around seven million people are photographed next to this casino—a place that locals are prohibited from visiting.

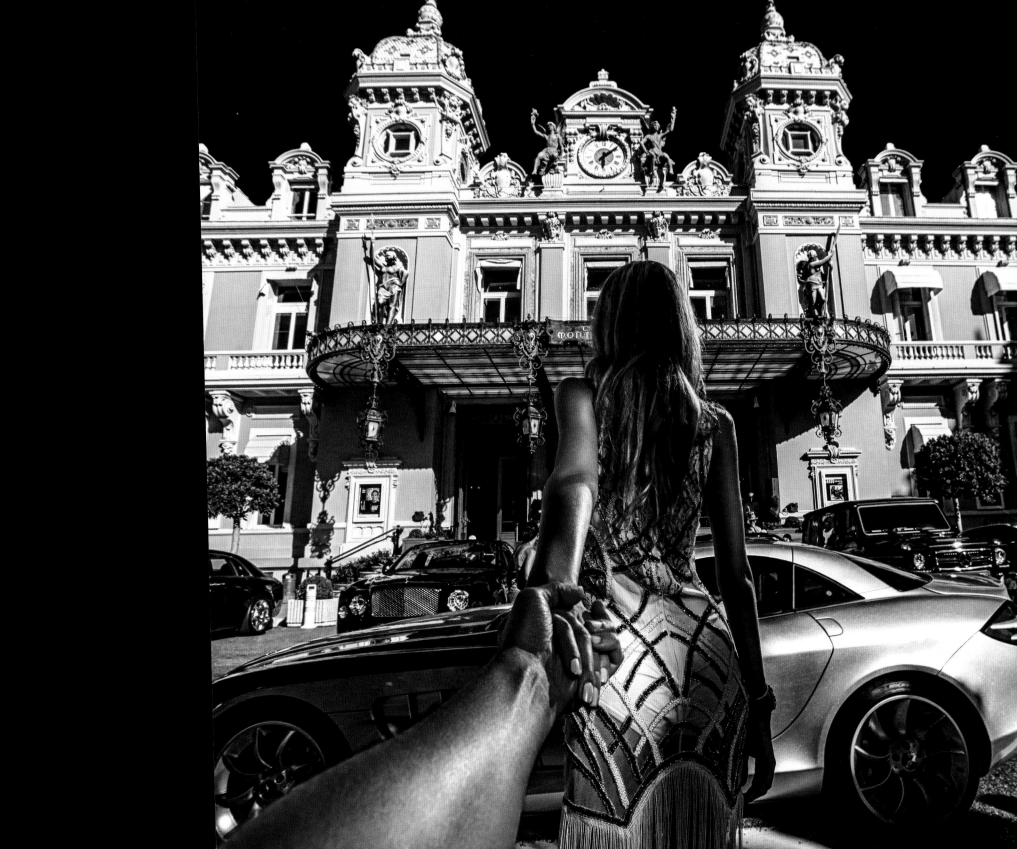

FRANCE
NICE

The Negresco Hotel

Perhaps it is the most famous hotel on the Promenade des Anglais. Today, it is more of a museum than a hotel. Its giant chandelier was created especially for the Russian imperial court, and an identical one is still in place in Kremlin.

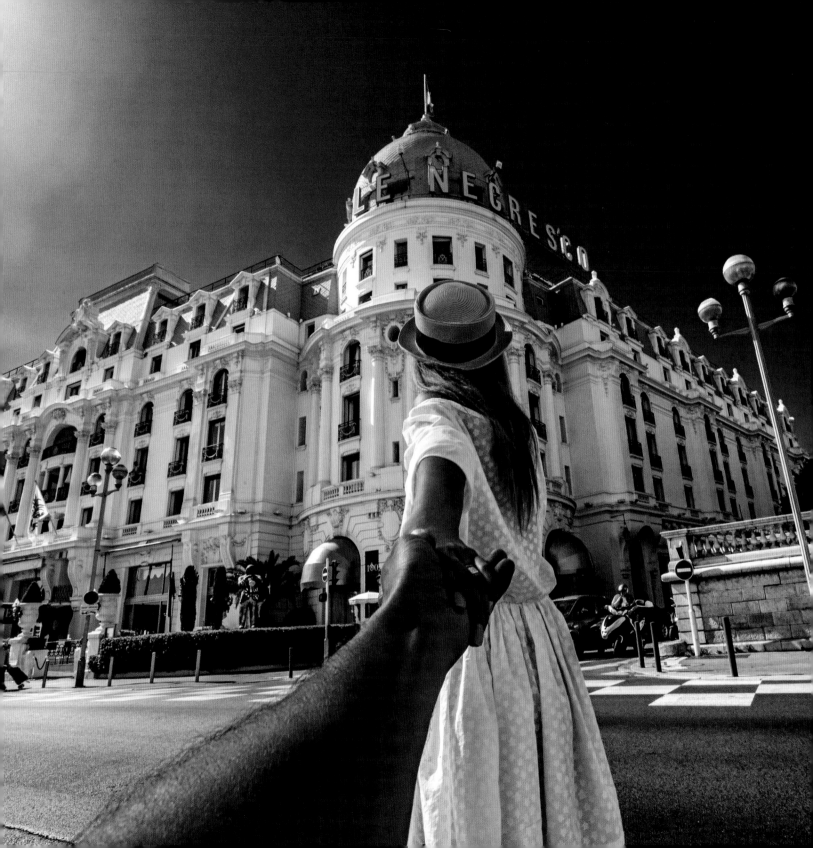

EZE VILLAGE

Top shot of Eze

This medieval village is situated at the height of 1,400 feet (427 meters) above sea level, just above the Saint-Jean-Cap-Ferrat peninsula. It takes your breath away. Here, you feel like a bird and the only thing left to do is to spread your wings and fly.

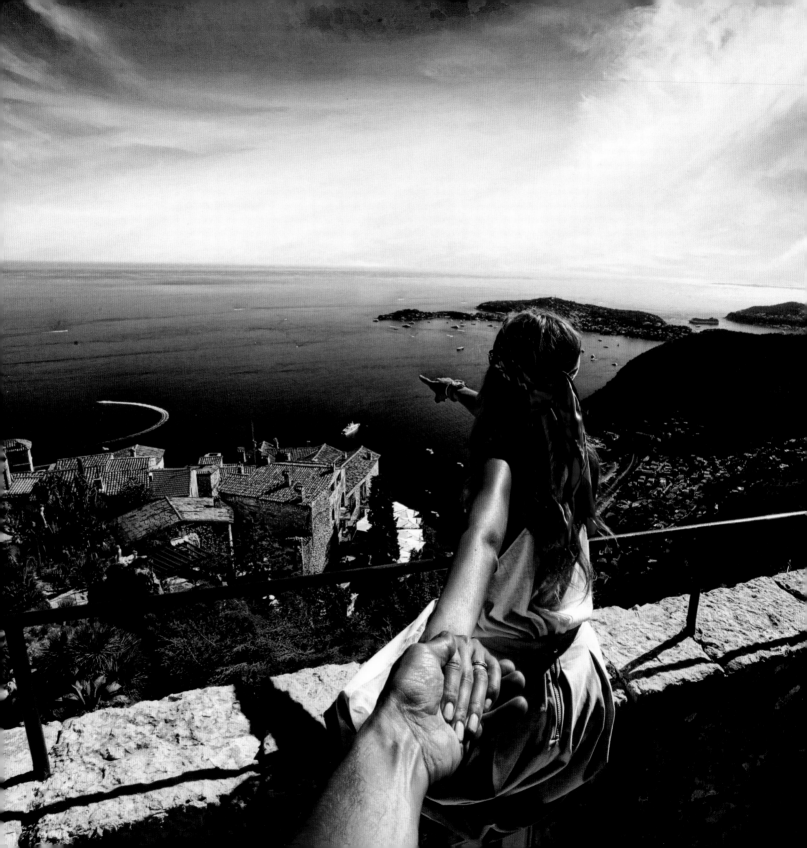

FRANCE
NICE

Top shot of Nice

I love this city for its freedom and spirit of life;
for its royal style and beach umbrellas; for
the aesthetics and mix of colors. At any time
of day, you can walk along the Promenade des
Anglais and touch the history of this city.

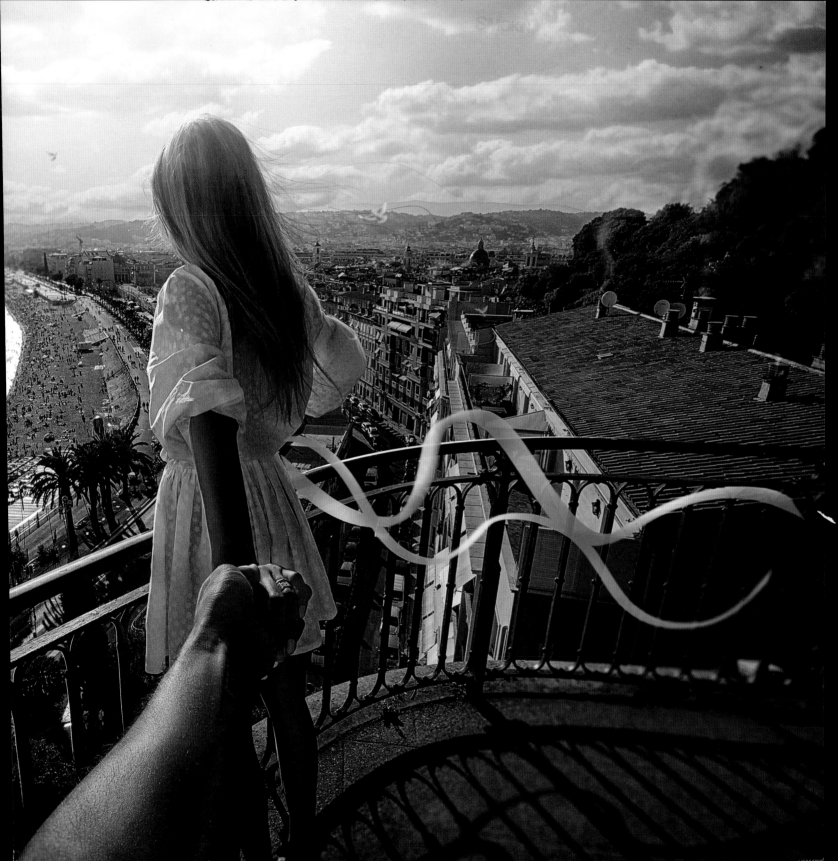

FRANCE
COURCHEVEL

Alps

What can be better than mountains? Only a slope of fresh snow where nobody has stepped before. You can't stop staring at mountains, especially when they are covered with snow and offer a skiing resort. In that case, you're going to want to stay there forever. Skiers and snowboarders, the scent of alpine cuisine and mulled wine. Eight countries share the mountain range that makes up the Alps.

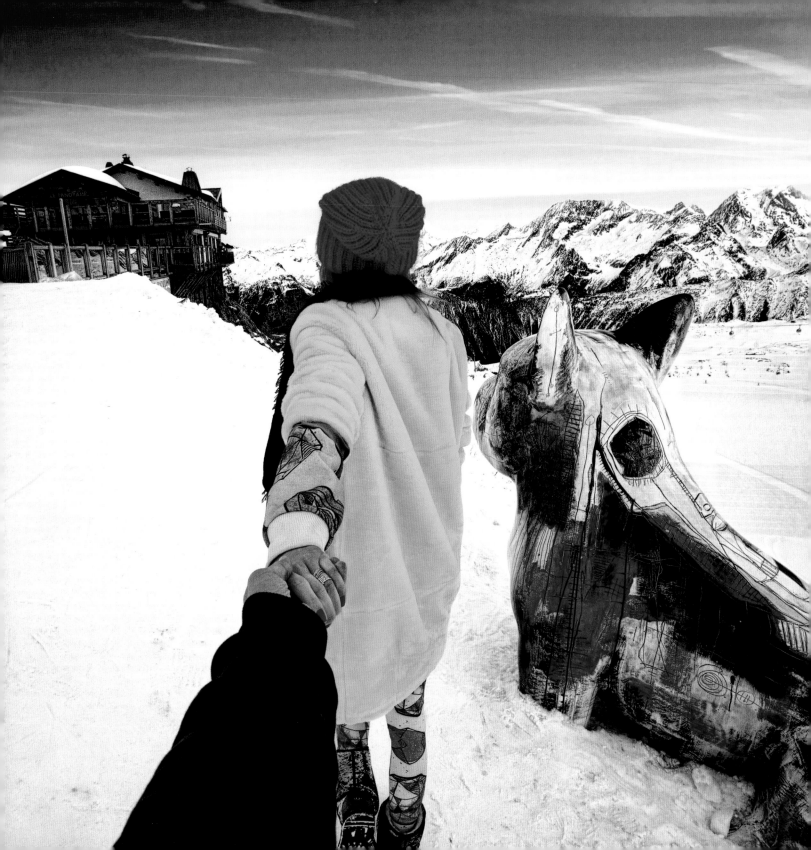

FRANCE
PARIS

*The Pompidou Museum
of Modern Art*

As one strolls around the delicate and exquisite Paris, one is shocked to suddenly find themselves beside a totally modern, artistic building. Fifty thousand exhibits of modern art are displayed inside this "contemporary art" storehouse.

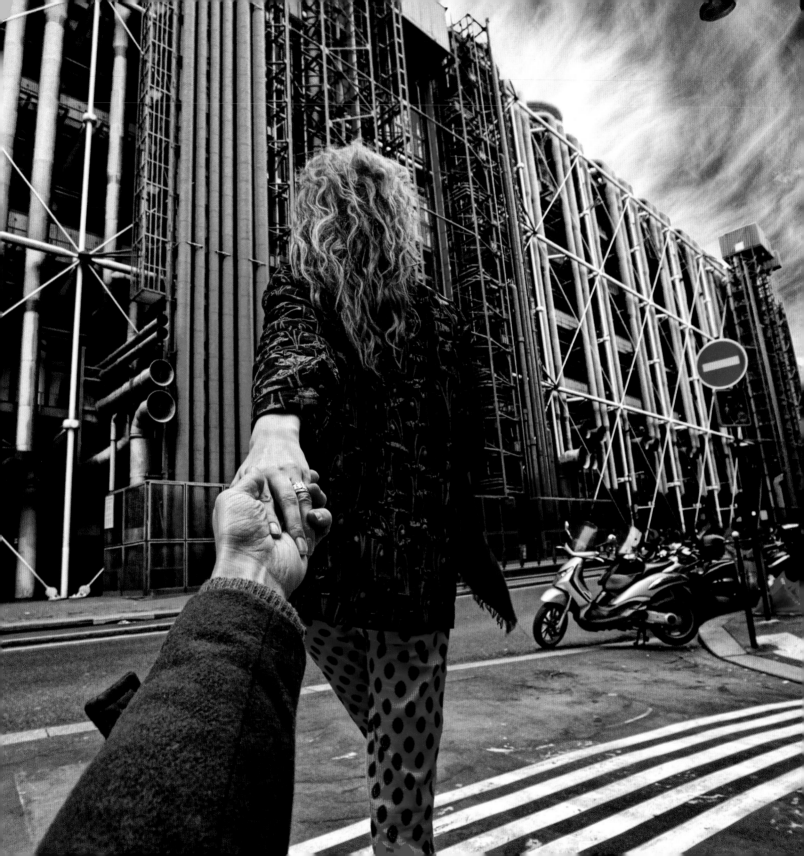

FRANCE
PARIS

Montmartre
Sacre Coeur Basilica

Tourists love this place, probably almost as much as the Louvre and Eiffel tower. The crowds of tourists flash their cameras and try to save this perfect solemn catholic temple in their memories. (And so do we.)

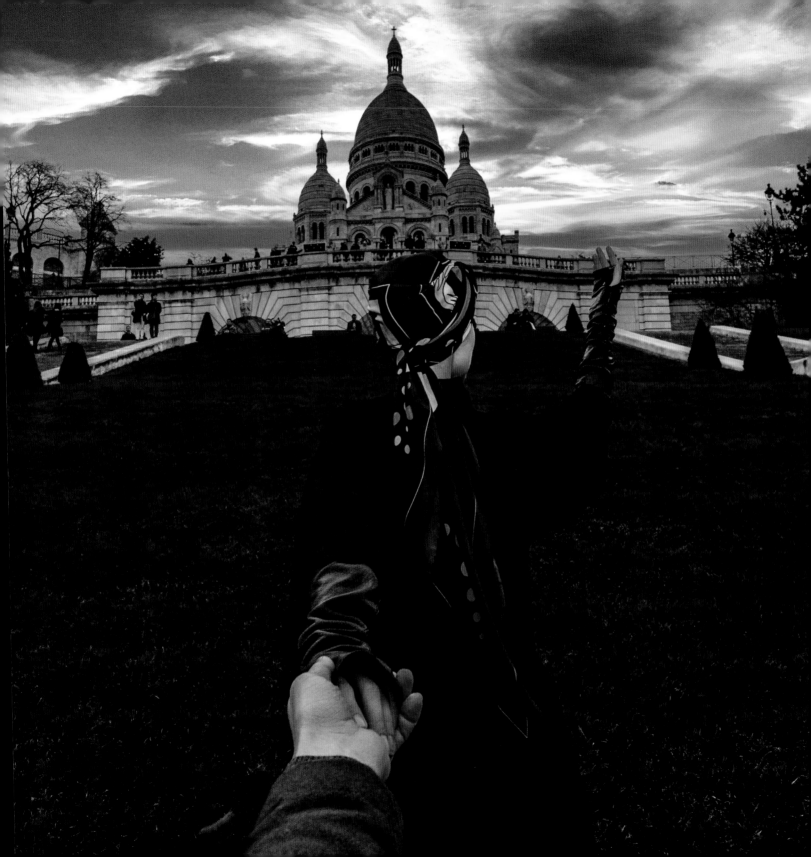

FRANCE
PARIS

The Louvre

Walls of French Renaissance and Baroque coupled with modern installments, The Louvre houses endless halls of evolving culture and history. Inside, seasoned intellectuals and young, curious minds gather to immerse themselves in the accomplishments of artists from around the world. Here, in the heart of Paris, time knows no bounds, honoring the past and embracing the future.

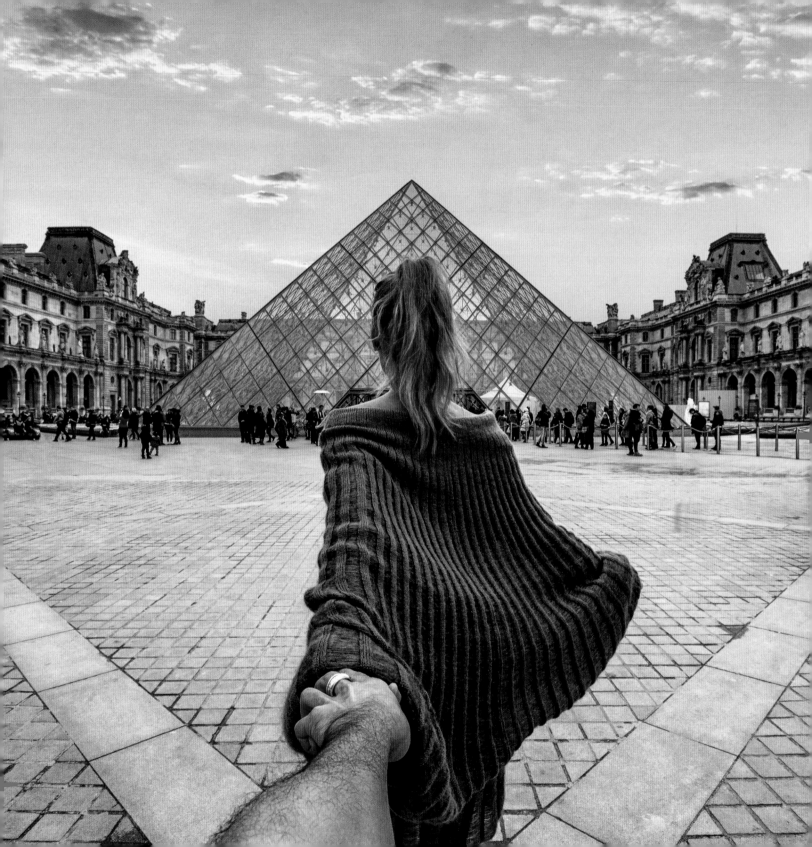

FRANCE
PARIS

Moulin Rouge

A legendary place in Paris. Full of history, broken hearts, and parties. The stories of Moulin Rouge are much more impressive and dramatic than the building itself. Toulouse-Lautrec, La Goulue, Jane Avril . . . You can feel their laughter and tragic fate in the air.

FRANCE
PARIS

Trocadero

This dress and hat were created by a talented French designer. It's the perfect expression of Paris's very special streets and unforgettable croissants, its genius writers and artists, houses with intricate ornaments, and slight perfume aroma! An optimistic realist–that's what this dress is.

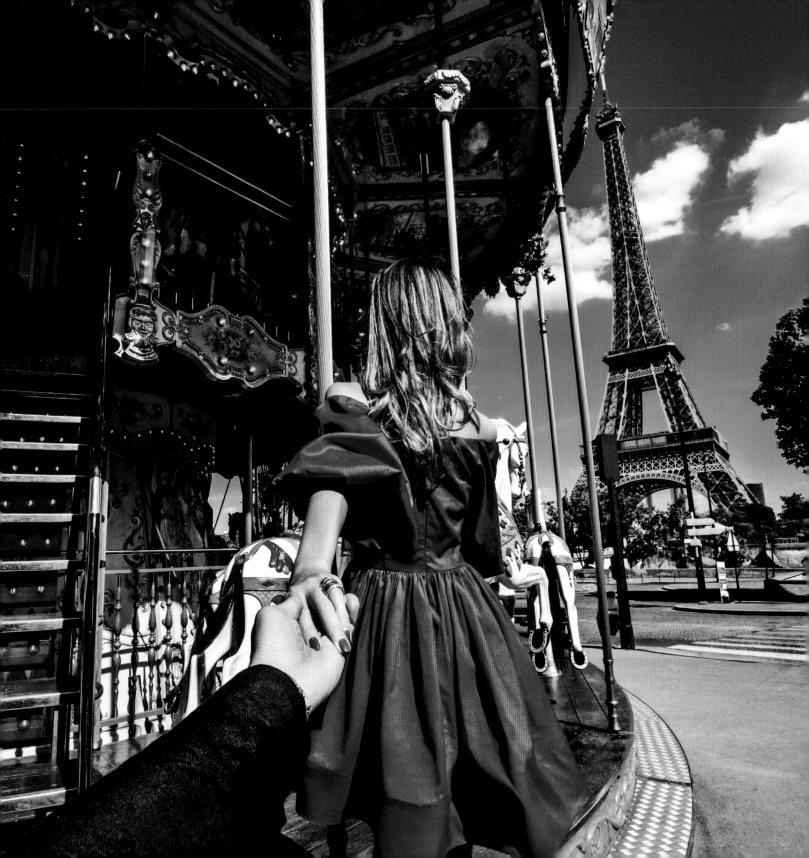

ITALY
ROME

The Colosseum

What we see today is only 40 percent of the original Colosseum, but we can still feel and touch all the power of this historic place. While trying on an Ancient Roman warrior costume, I drew the attention of the local actors who use such transformation every day to earn money.

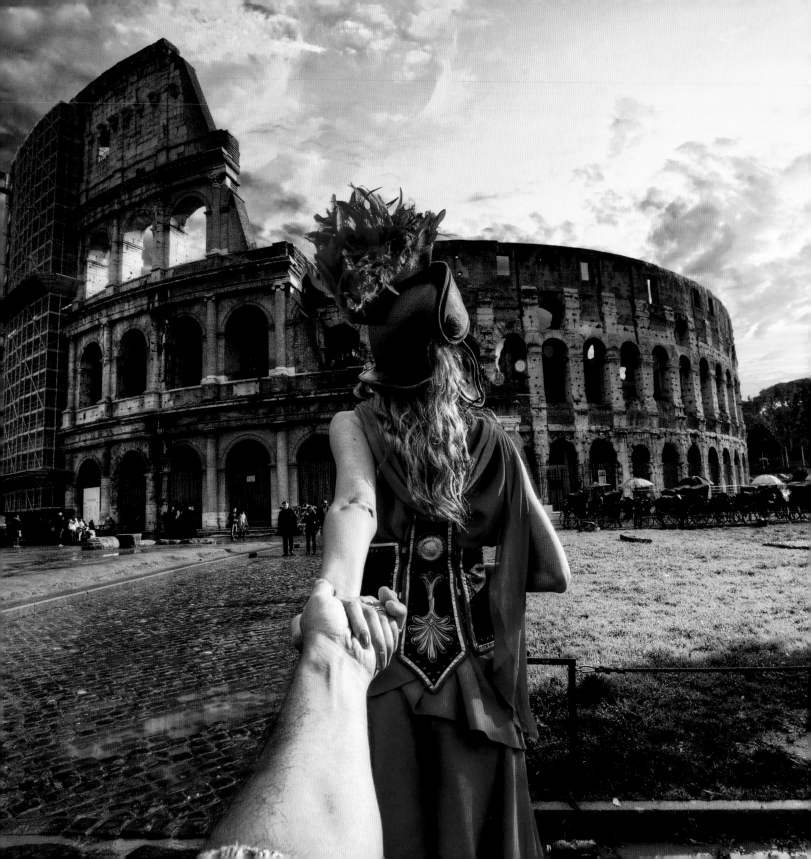

ITALY
ROMA

Il Vittoriano,
view from above.

In Rome, you don't count in centuries–you have to use millenniums and BC or AD can both be used. We are standing on a very modern building (in Roman terms); it is only forty years old. But it is so great to appreciate the beauty of the city from above.

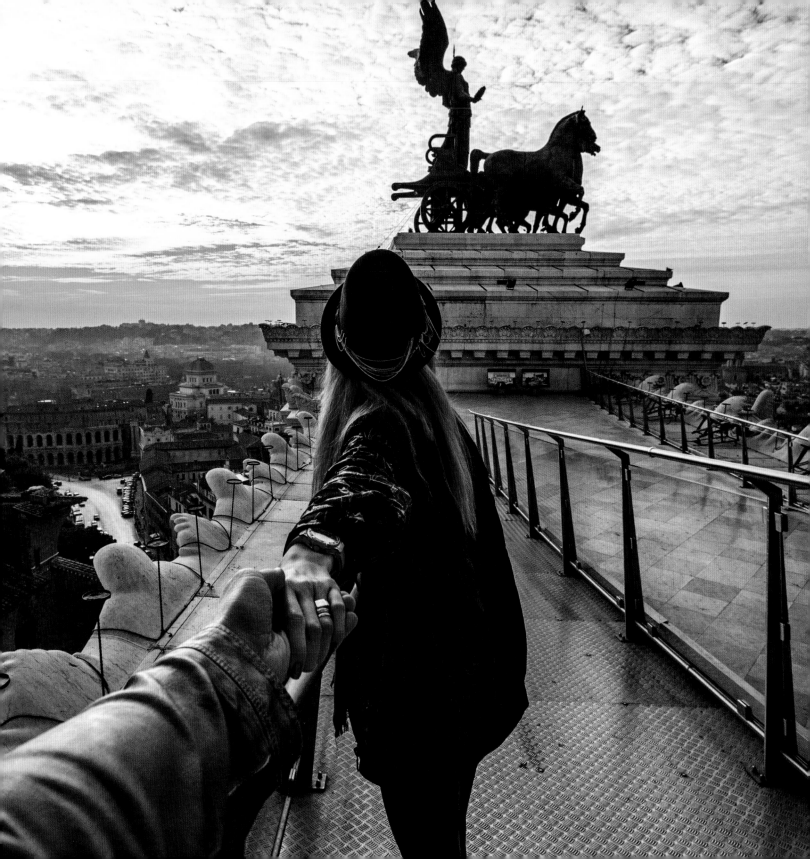

ROMA

Cathedral

A ringing noise of silence is what we heard the very second
we entered this sixteenth century cathedral. It pierced us and it
seemed to me that even the camera click went unheard.

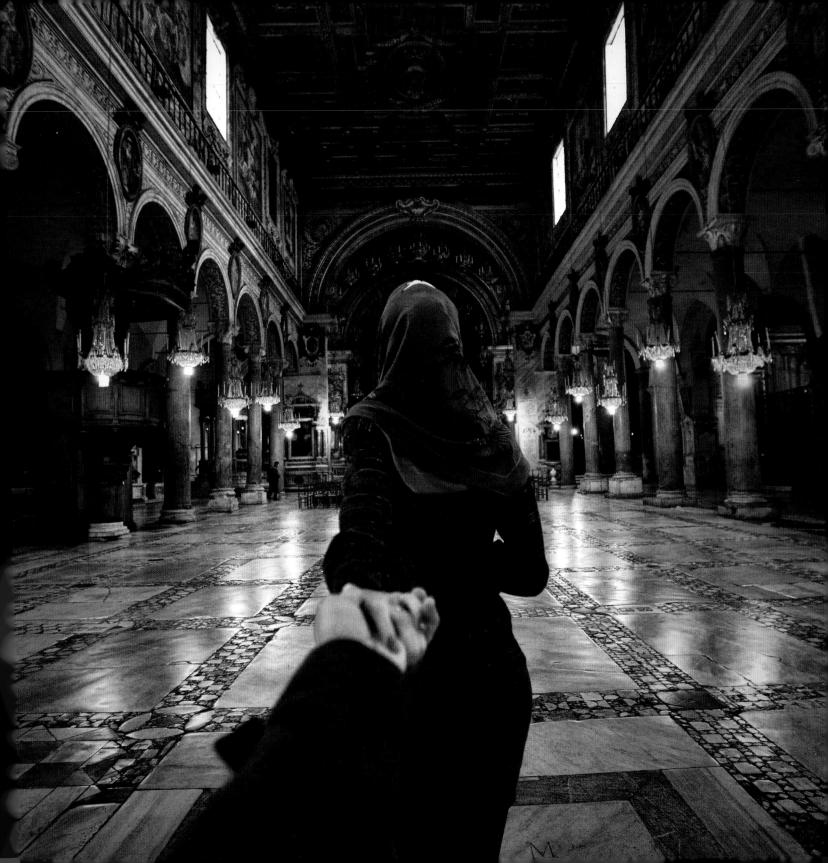

ITALY
MILAN

The Duomo Cathedral

Perhaps one of the most popular places in Milan. It took five centuries and more than 180 architects, artists, and sculptors to design the Duomo Cathedral. We happened to select the best angle.

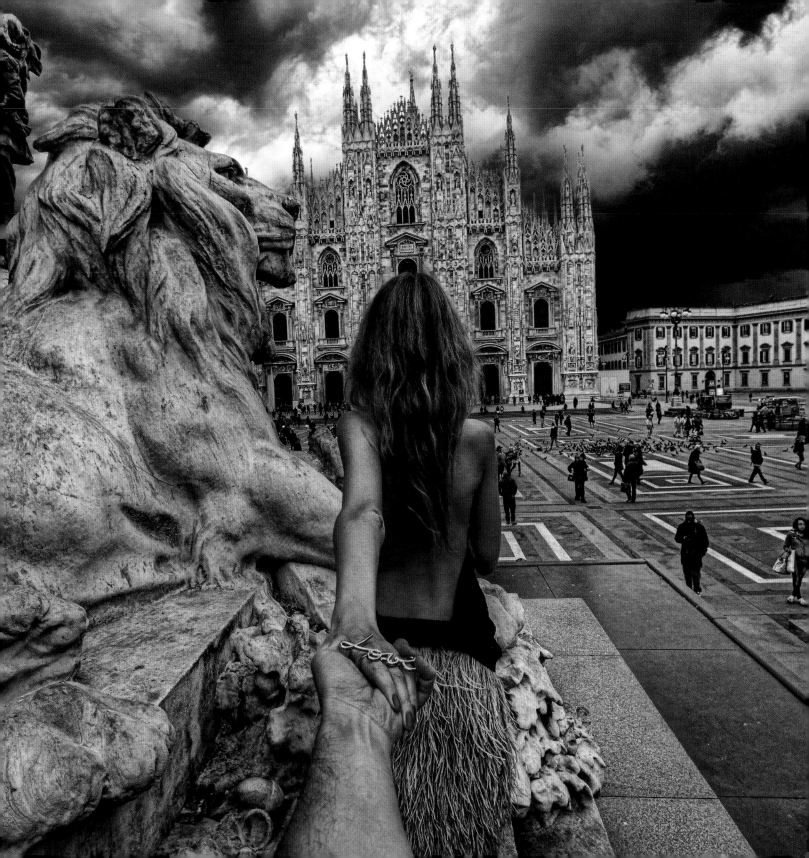

MILAN

Piazza del Duomo

Sometimes improvised photos become masterpieces. Everybody knows there are lots of doves in Milan. While strolling along the square, we had the idea to capture the free flight of the birds. Who would've known that those spoiled representatives of the feathered tribe are so lazy and would not even try to fly?

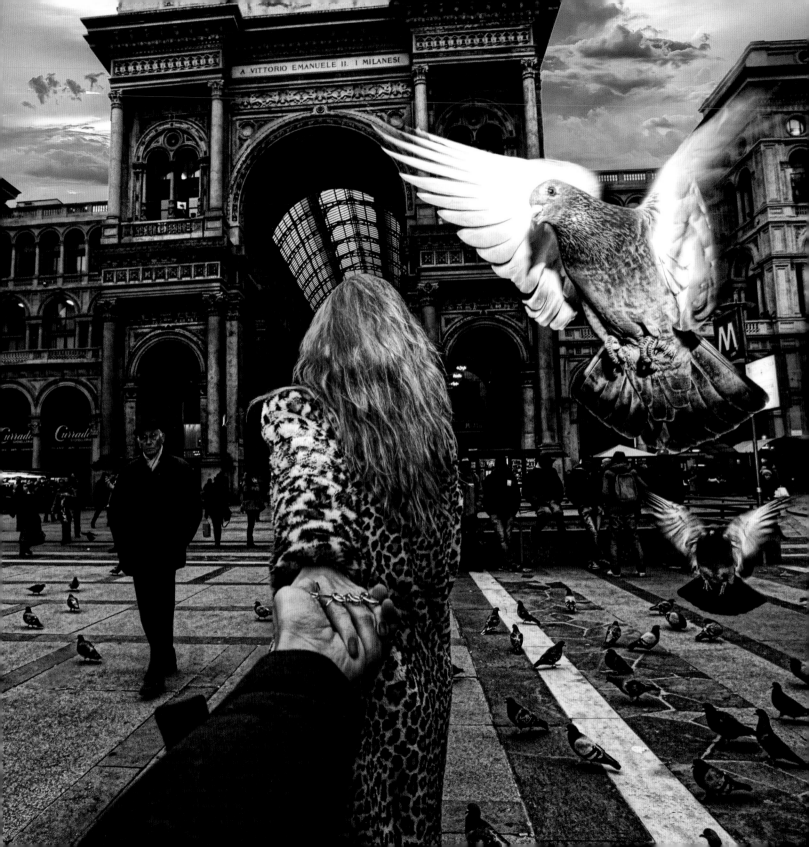

VENICE

Venetian Mask

What can be more desirable than mystery? Perhaps a mysterious stranger who takes your hand and pulls you to make you follow her. That is how we perceived Venice ...

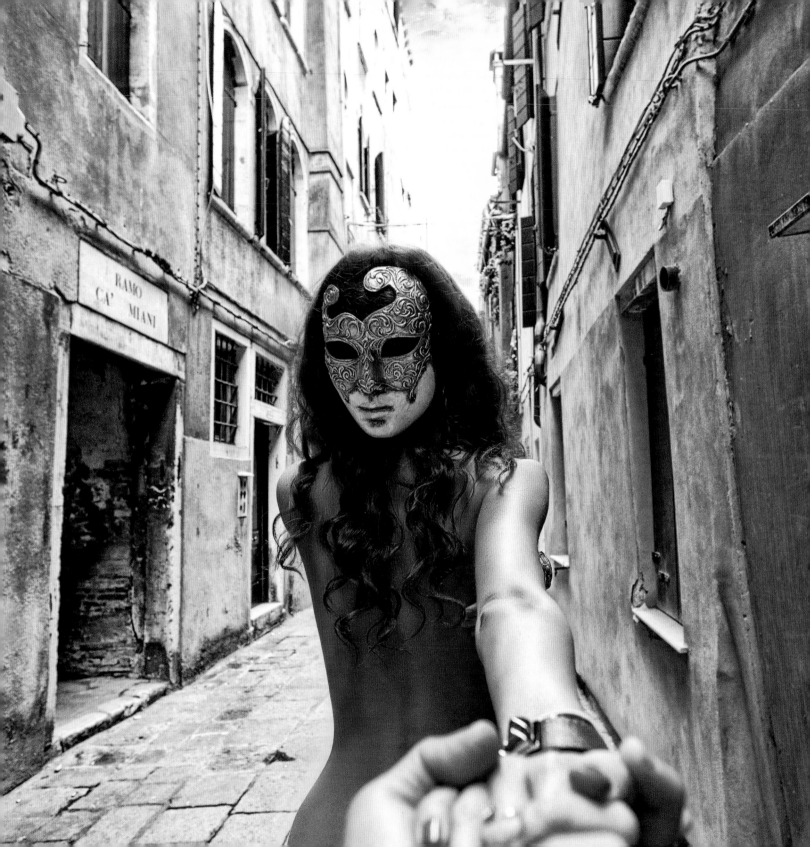

ITALY
VENICE

Piazza San Marco

In our opinion, this is one of the most romantic and mysterious cities in the world. It is so special with its distinctive character resembling a girl from a noble family who ran away from her date to a ball . . . of course, wearing a mask.

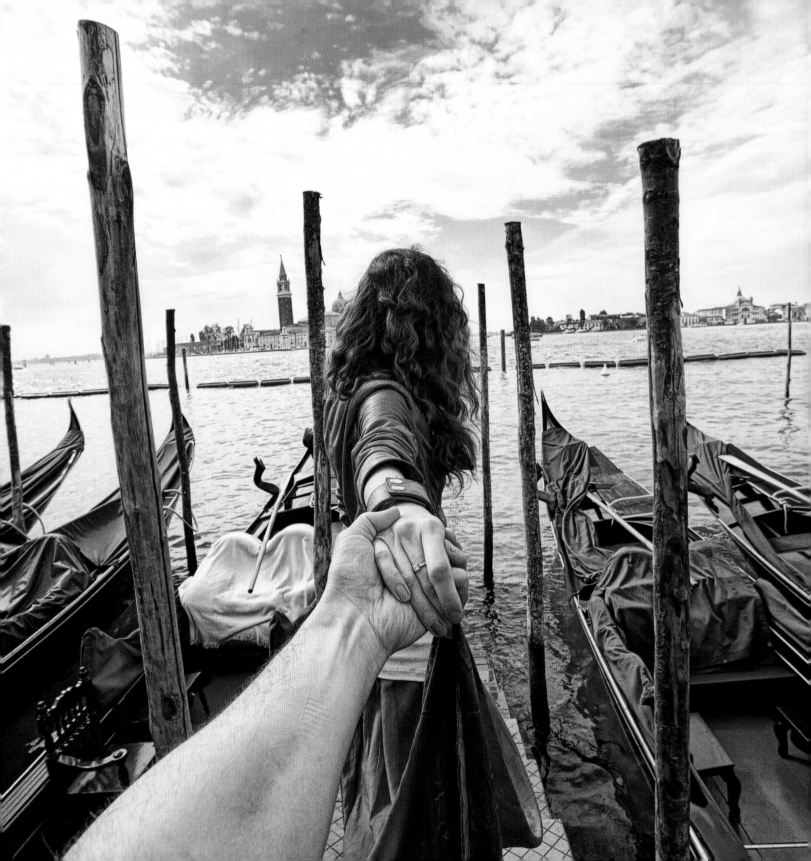

ITALY
VENICE

Canals

Canals, narrow streets, boats, masks, shadows, unfinished stories, and turns . . . You must only get into a gondola to find out someone's secret.

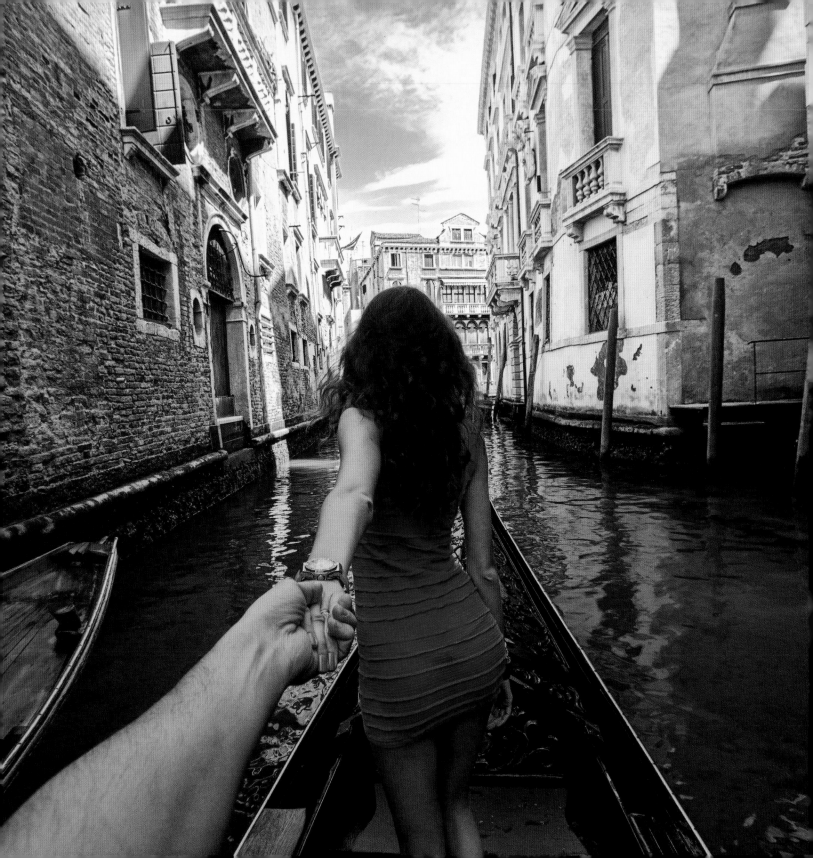

RAVELLO

Souvenir Tunnel

Italy is an amazing country, very different in the north and in the south. Incredibly delicious food, beautiful nature and, most importantly, the people . . . Italians are the main landmark of their country.

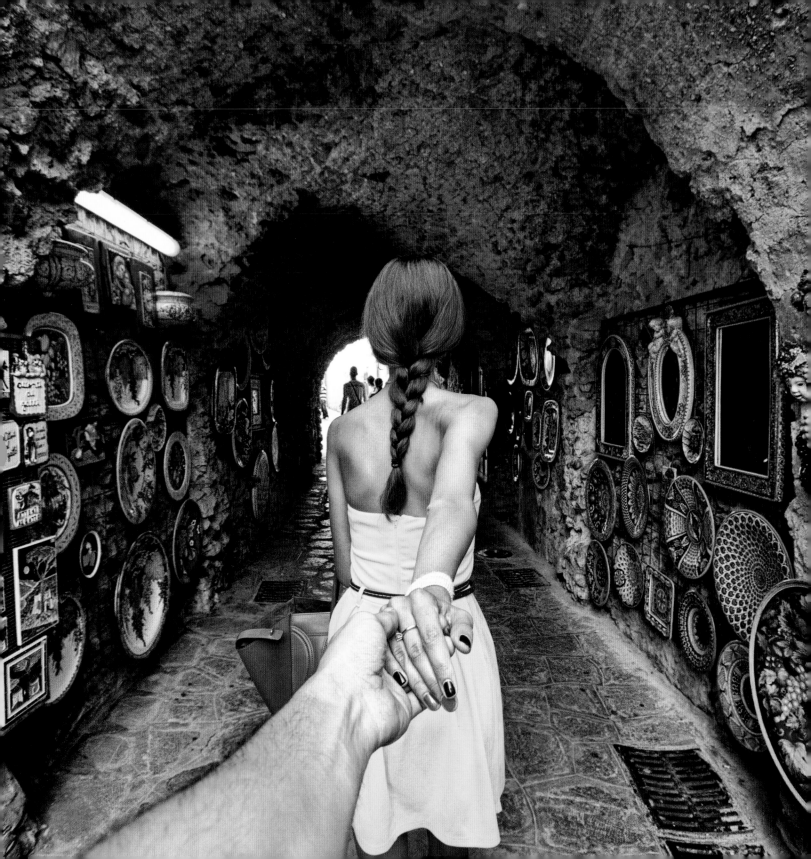

GRANADA

Alhambra

I glanced over the city, put up my fan, and for the moment imagined I was dancing. I love Spain for its emotions, strict principles, and inimitable beauty.

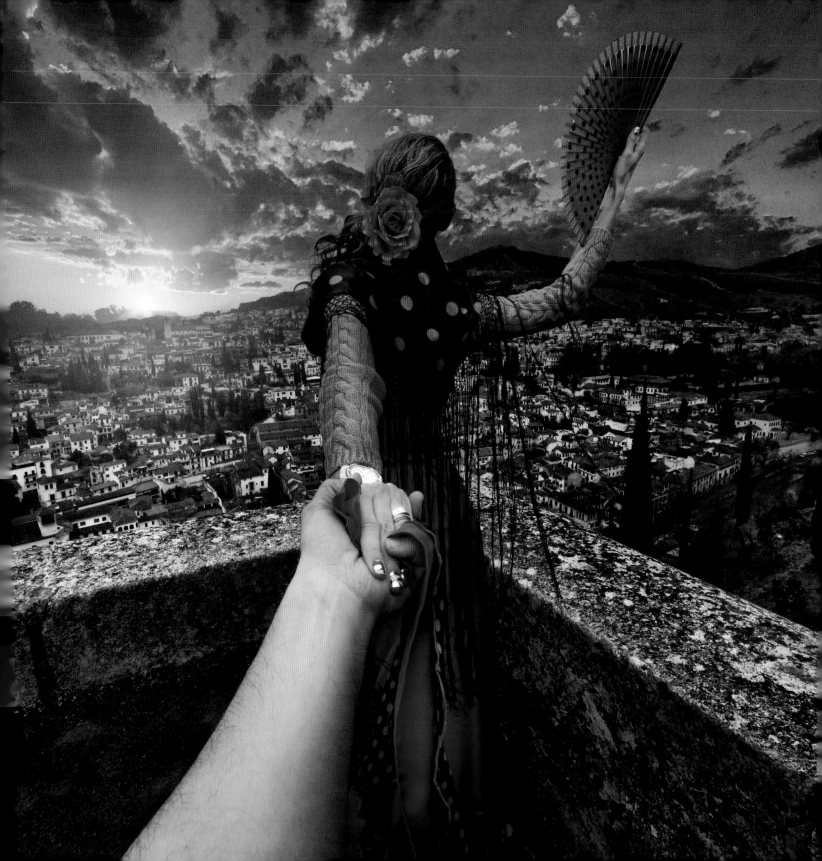

BENIDORM

Poniente Beach

We came to Benidorm in winter when the coast was so peaceful and no one was around. We immersed ourselves in the winter sun and spent a number of hours on the beach silently watching the sea.

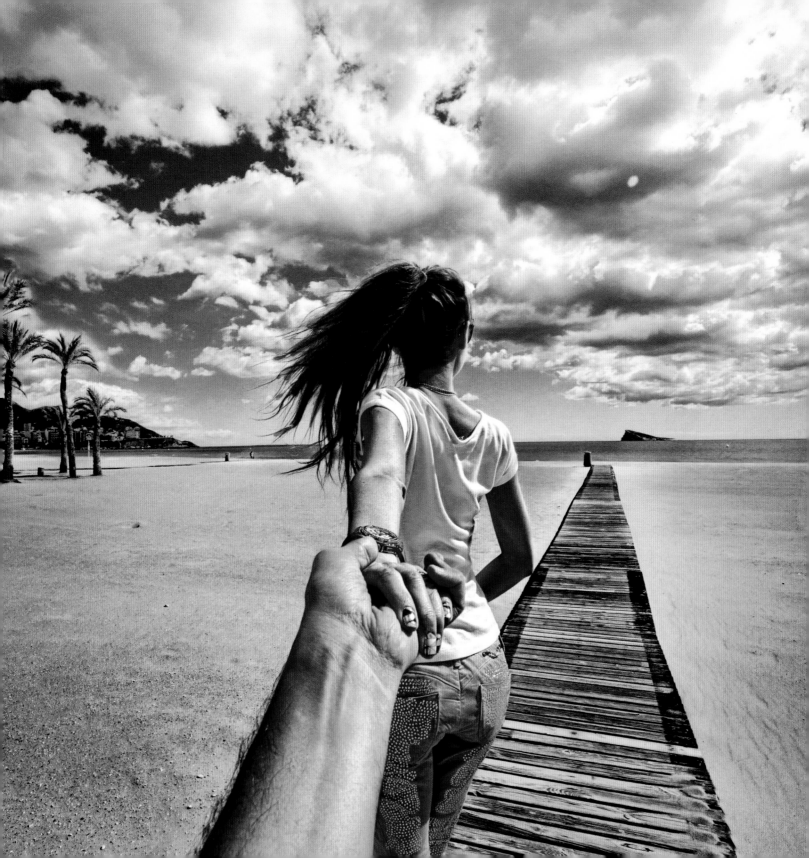

SPAIN
GRANADA

Alhambra

For a number of hours we were captured by the halls and
spaces of Alhambra. There are so many tourists and queues,
but it is totally worth it... The history of Southern Spain
is in the walls of Alhambra...

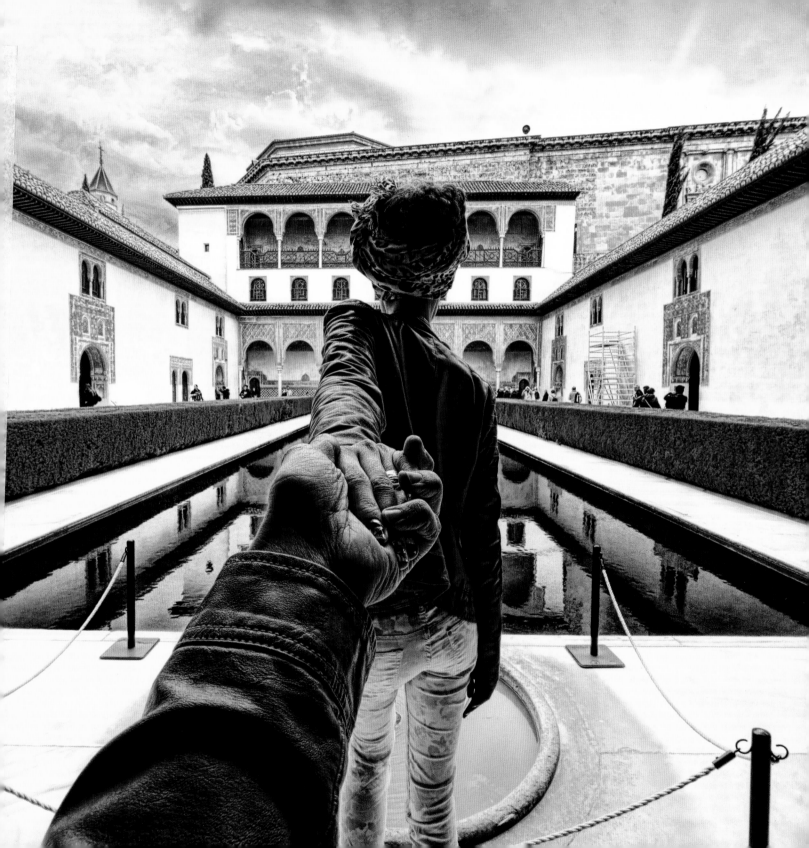

BARCELONA

Graffiti Door

The first photo from the Follow Me To series. It wasn't taken on purpose. It became quite symbolic in the end: I am standing in front of a fantasy-style painted door, unaware that behind it such a large "Follow Me To" project would be born.

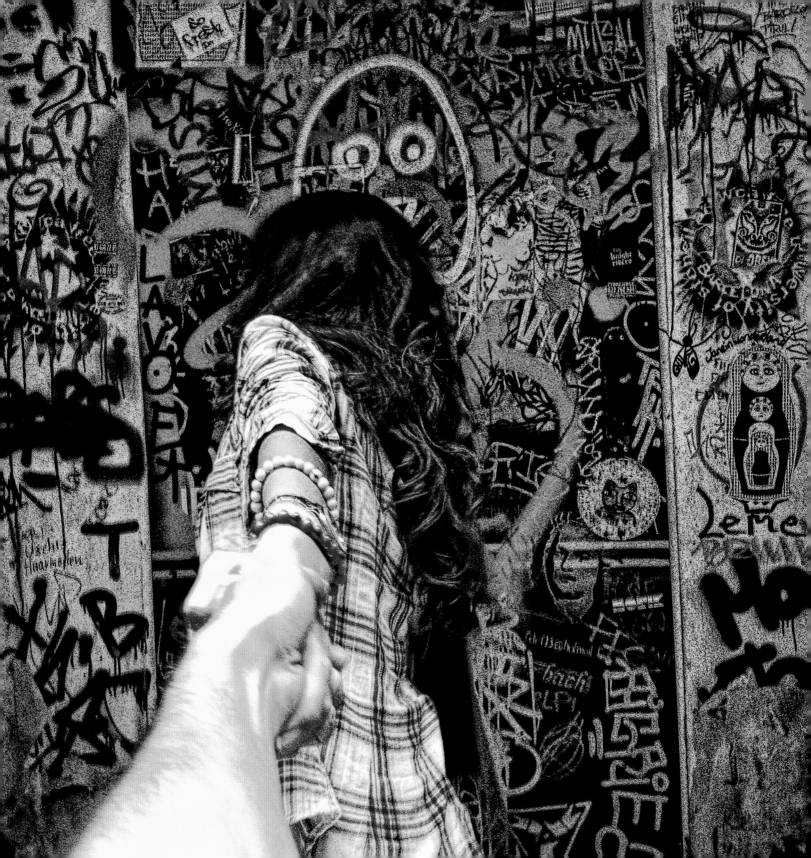

BARCELONA

Barcelona is a very unique city. Many things happened during its twenty-three-century history. In this city, I am confident in saying that everyone can find a place that suits him. This city enchants and bewilders, it makes you want to go further and learn more. There's so much history here.

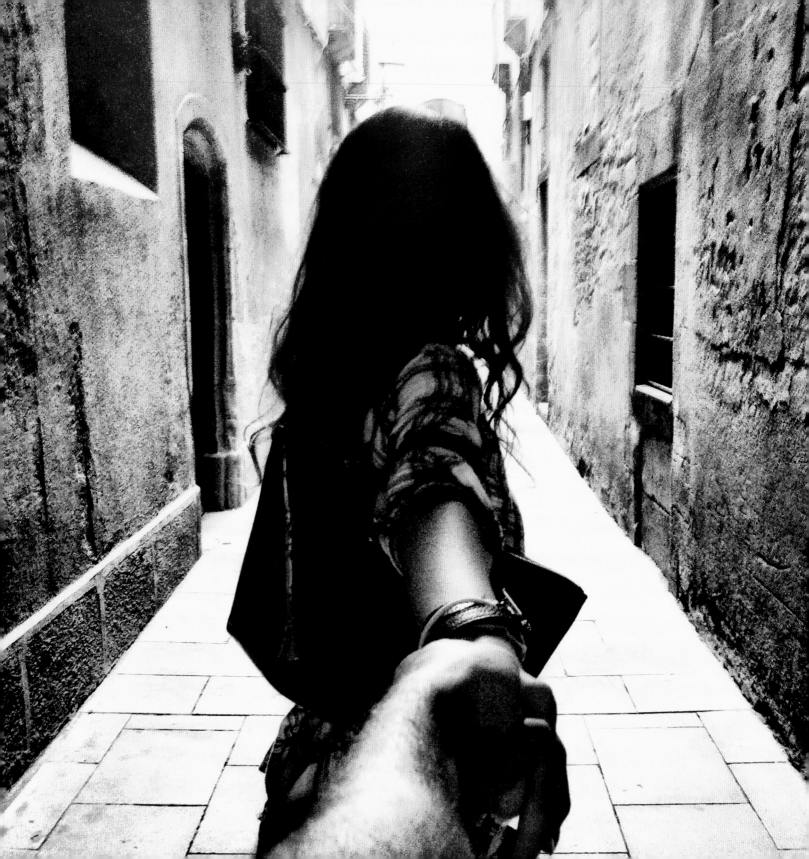

MADRID

Corrida

Corrida is a significant part of the Spanish culture and is a very entrancing show. Brave toreadors seem to dance, "playing" with the bull. I have not met anyone who has remain untouched.

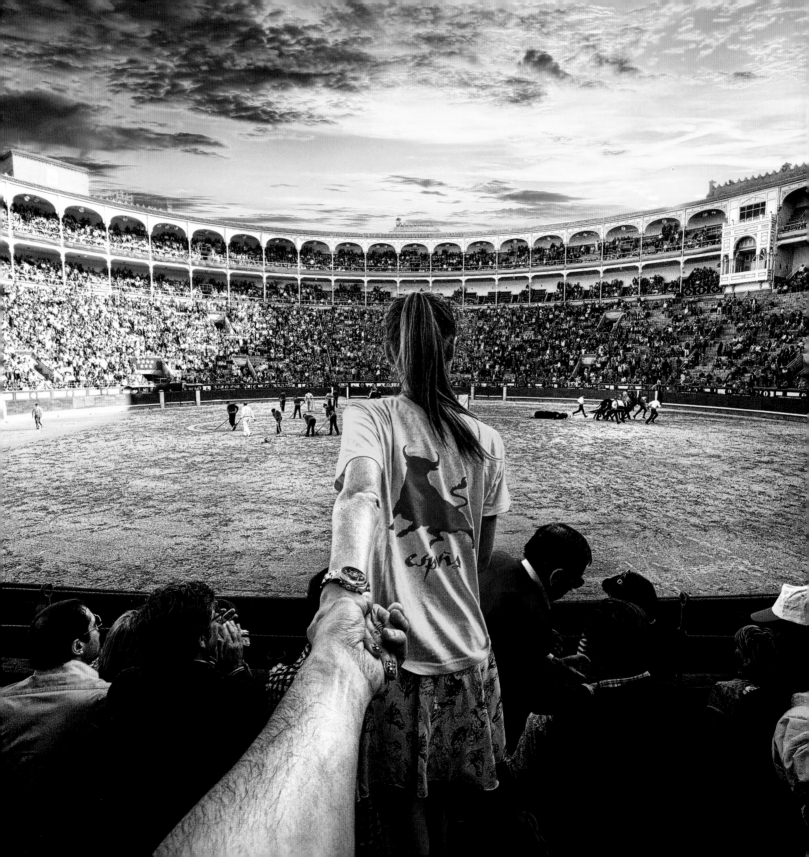

SPAIN
MADRID

Crystal Palace

It was built in 1887 and copied the style and image of a similar building in London. Its construction looks so fragile from the inside, but its inside is actually a durable combination of iron and glass. Just like the people.

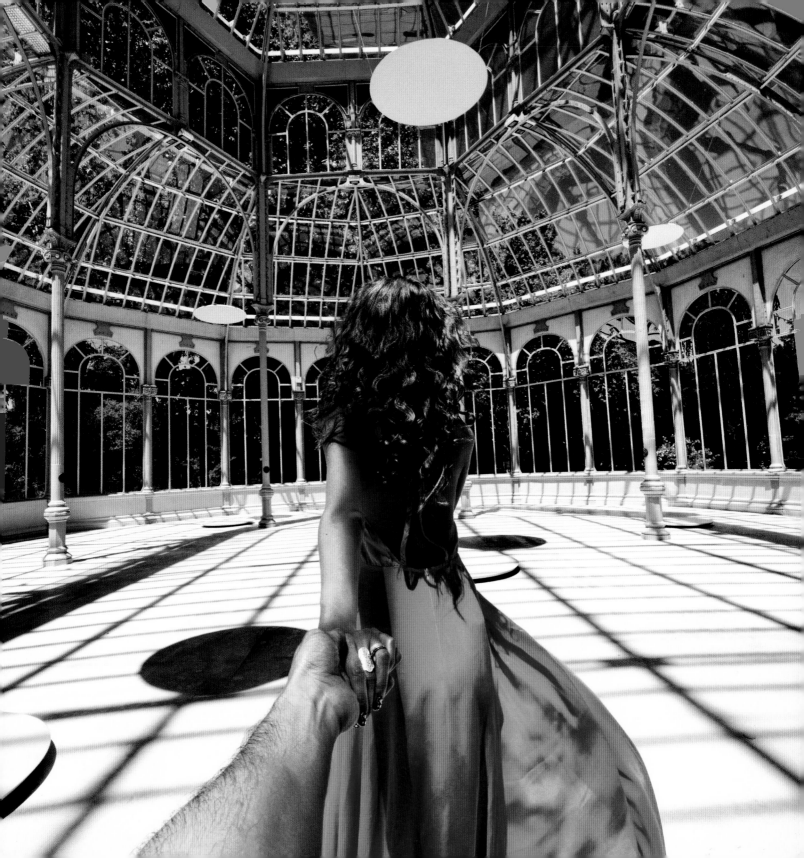

MADRID

The Roof

Madrid is the sunniest city in Europe! There are around 250 sunny days each year. The locals are so welcoming and warm that it seems they all carry the sun in their pockets.

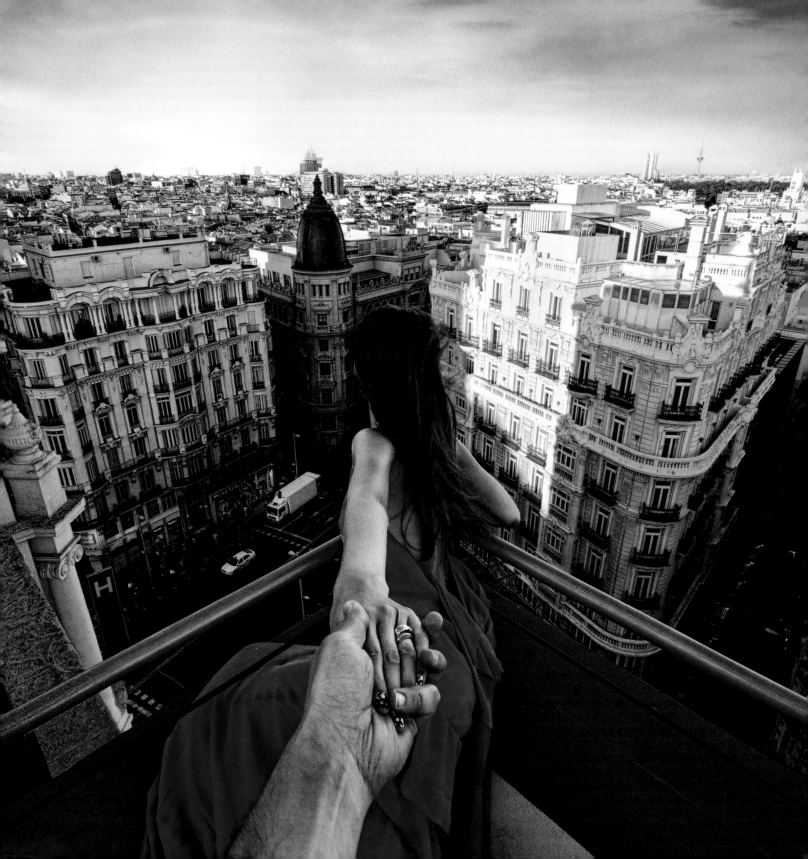

BARCELONA

Hotel Praktik Rambla

Perhaps there is no need to mention the great facade architecture of this city, but I would like to note the impossible views inside the buildings. For a moment, you just want to become one of the lovely statues yourself.

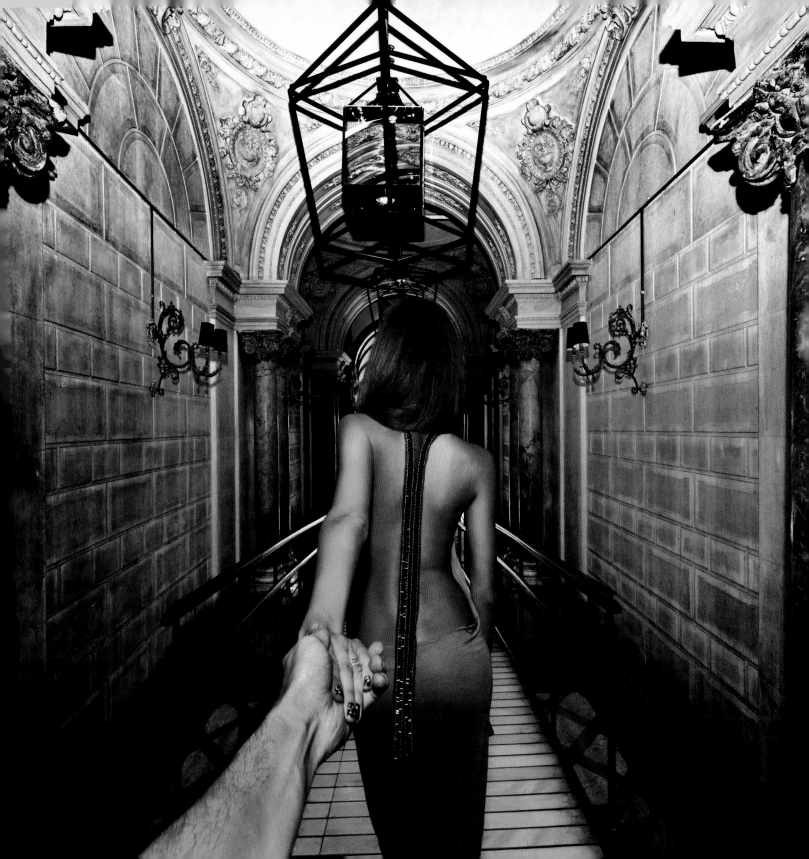

SPAIN
BARCELONA

Boqueria

The first mention of the Boqueria market in Barcelona dates back to 1217. The colorful shelves of products seem to form a perfect piece of tapestry. It's a noisy place where all the guests of Barcelona meet. You will rarely find a local here. This place seems similar to the theater, as vivid sellers have the same acting talents as professional actors.

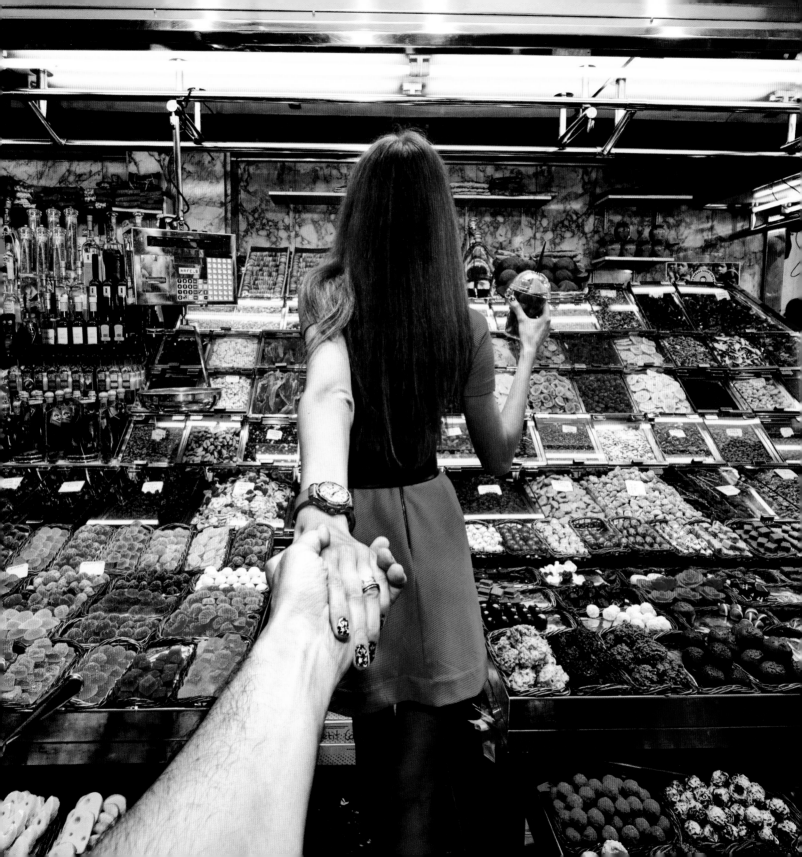

BARCELONA

Port

Port cities are usually romantic and have an incredible variety of fishes in the restaurants. The history of the port of Barcelona is almost two thousand years old. The district around the port has seen so many stories and keeps so many secrets. . .

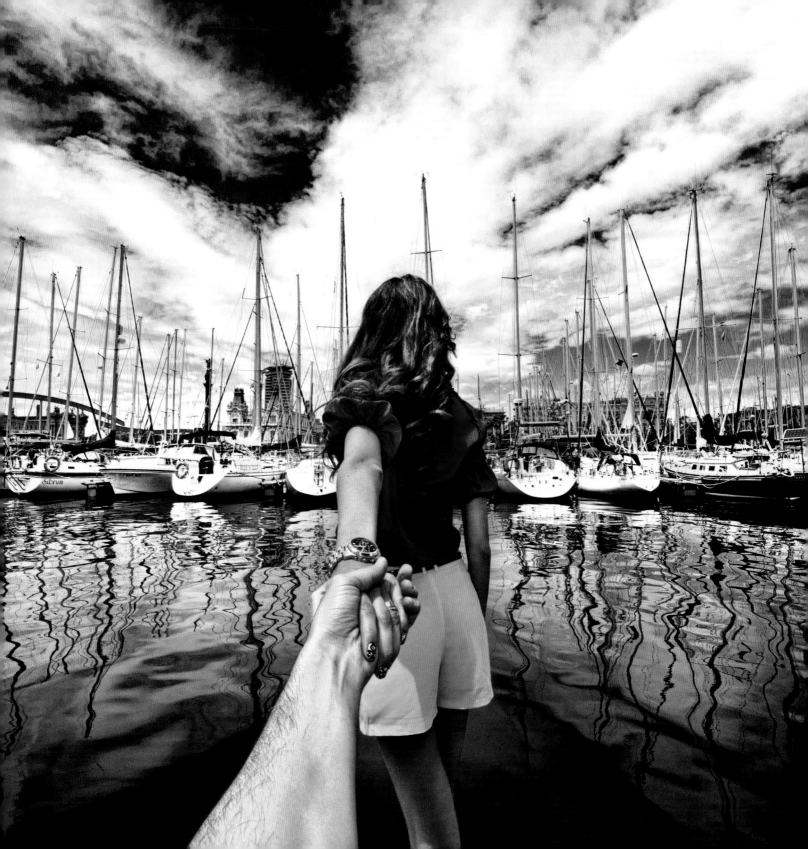

SPAIN
IBIZA

Old Town

A lot of people associate this city with endless partying—and they are right! But we have decided to show the picturesque parts of the city as well—which are often left behind. This is the old town!

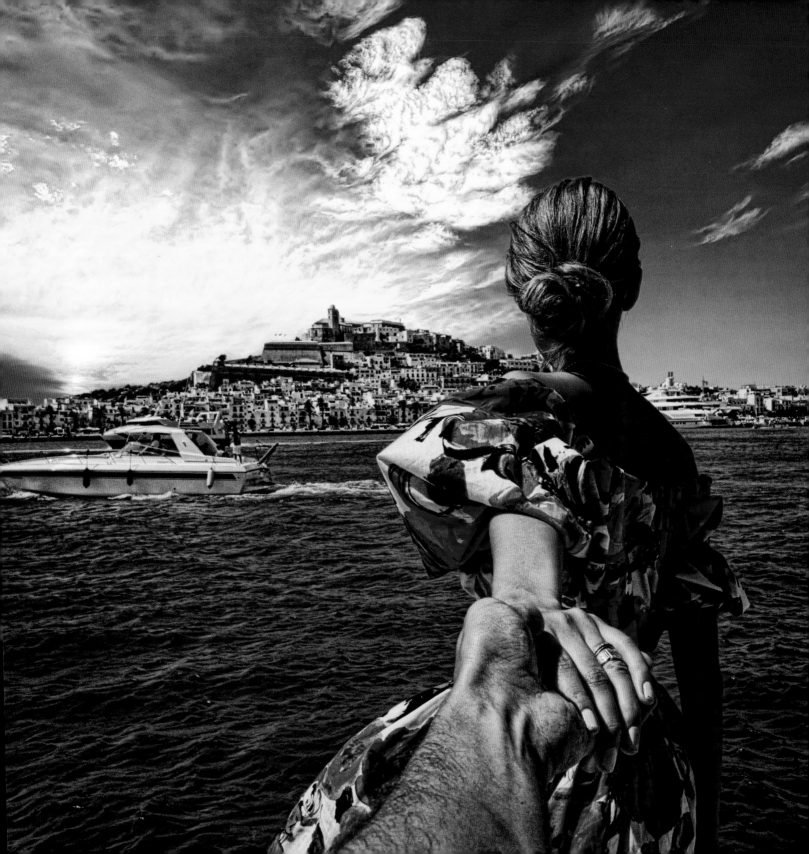

GERMANY
BERLIN

Memorial to the Murdered
Jews of Europe

Memorial devoted to the murdered Jews of Europe in the
memory of Jews—victims of the Nazis. The idea of its
creation came to German publicist Lee Rosh as far back
as 1988 but it was only in 2005, seventeen years later, that
it was constructed. It is a place where your skin crawls and
you seem to hear calls for help and see horrible images when
walking around this cold concrete forest.

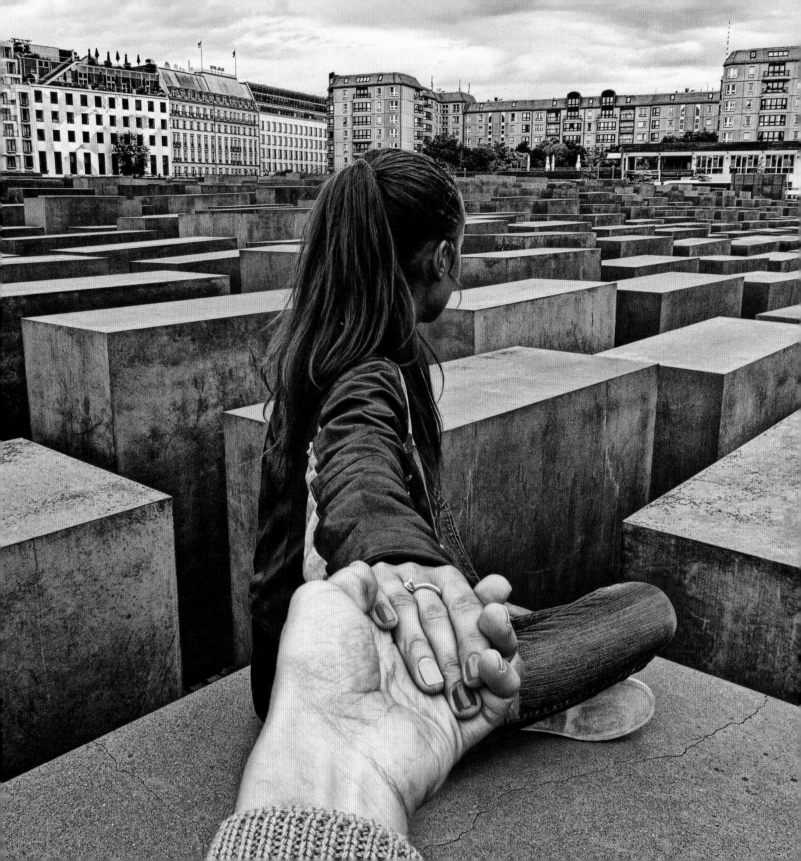

BERLIN

Museum Island

The Berlin Grand Cathedral is the first building that greets you on Museum Island. As of 1999, this unique building and its cultural ensemble was added to the UNESCO world heritage site list. This is the largest protestant church in Germany. It has seen a lot in its life: reconstructions, the war, and tourists' cameras from all over the world.

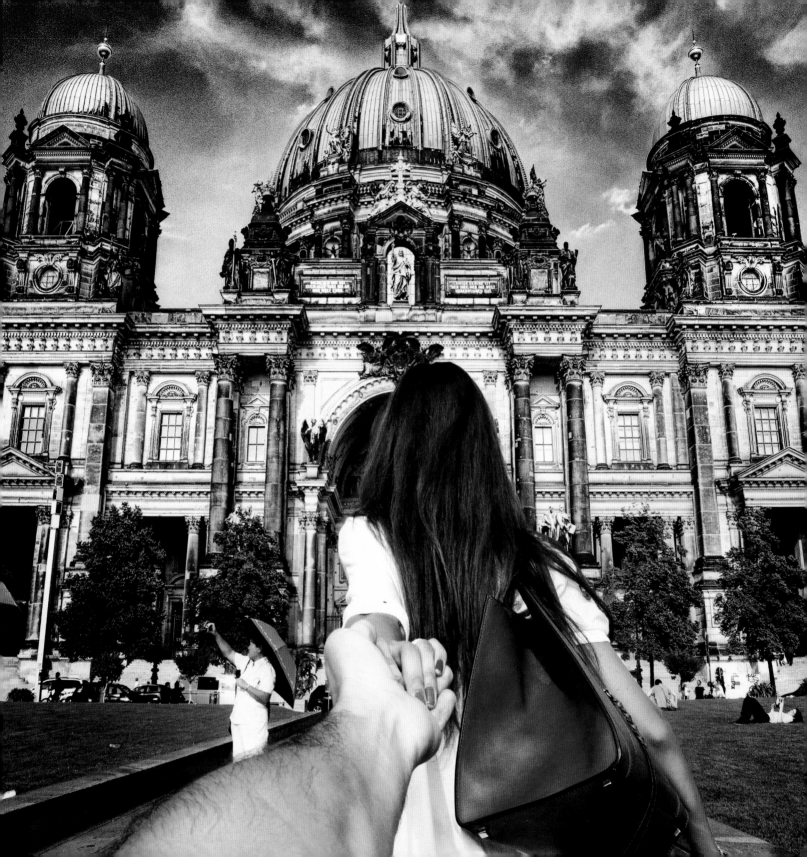

GERMANY
BERLIN

Brandenburg Gate

A legendary place . . . Previously, this structure was called the Peace Gate, but it has not seen any peace. In the end, the gate became a symbol of Germany and Berlin reuniting after the country was occupied by American and Soviet troops.

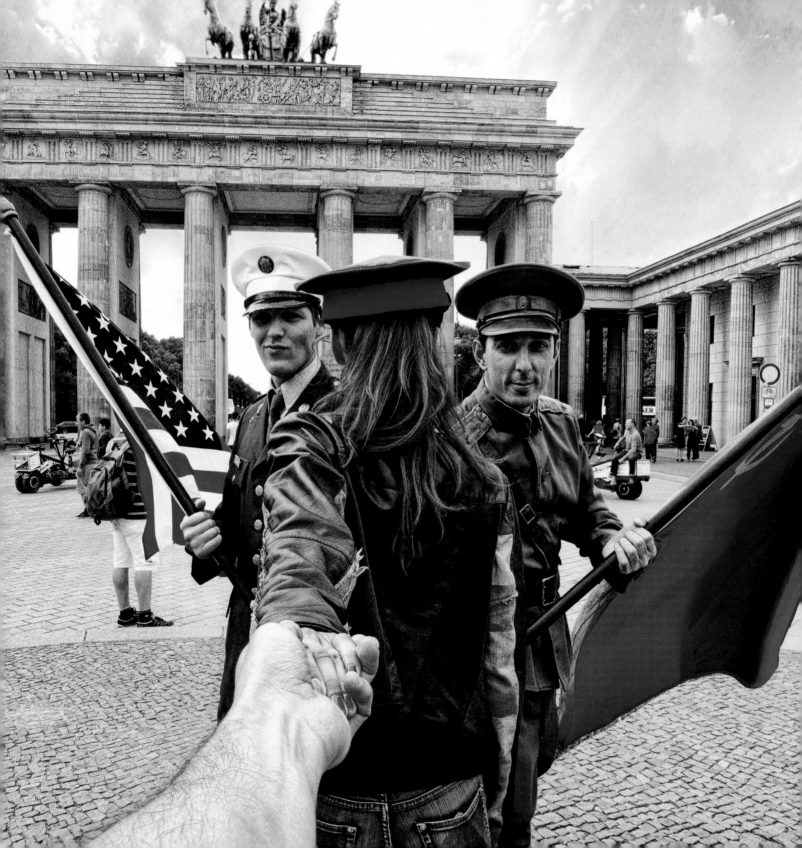

GRAZ

Fields

When you manage to escape the cold hug of the city and seek out wild nature, you are so filled with grandeur and endless freedom . . . Freeedoooom . . .

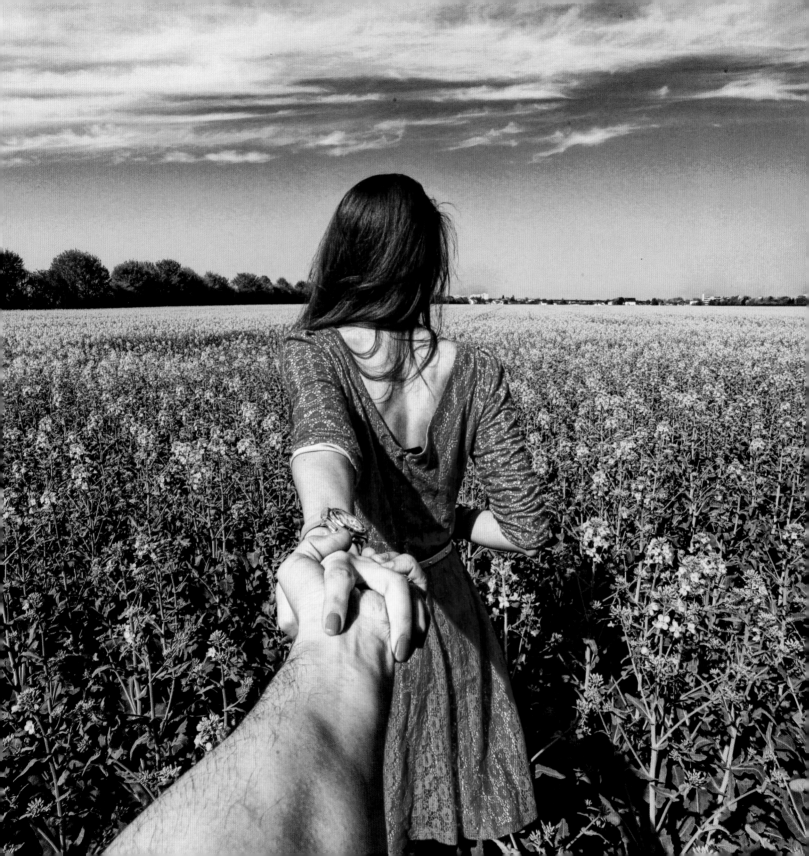

RUSSIA
MOSCOW

Red Square

Here, you are in the heart of a country with rich history. Your soul is touched by the bells of the Spasskaya Tower and St. Bazil's Cathedral. According to the legends, the architects who built the cathedral made it so beautiful they were blinded by Tsar Ivan the Terrible! Every time you pass this place, you feel like you are in a storybook.

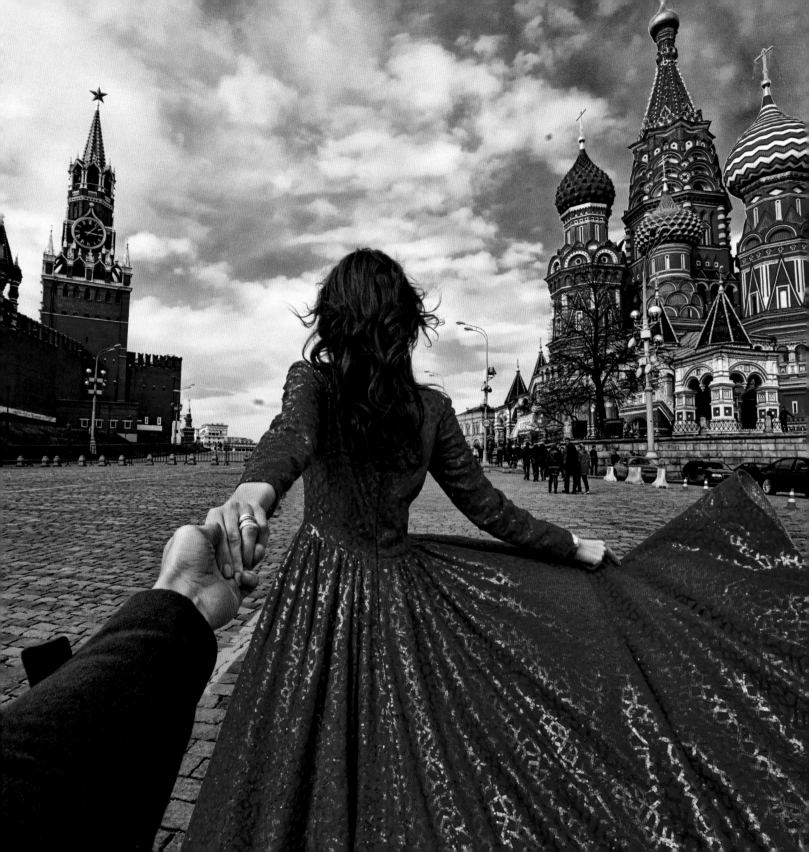

RUSSIA
MOSCOW

Izmailovsky Kremlin

Russia is an exceptional country of contrasts, with rich history and inexplainable human spirit. The Russian architecture leaves you astonished while the cultural heritage of the country touches the heart. This beauty bewilders you and the splendor of the domes makes you want to look up.

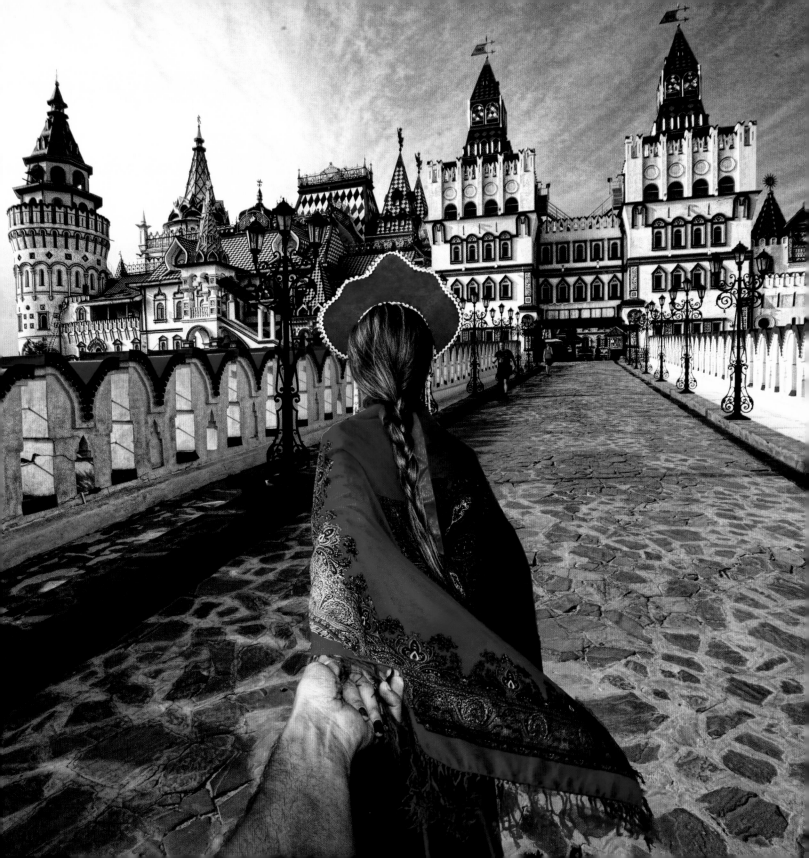

RUSSIA
SOCHI

The Olympic Flame

The twenty-second Winter Olympics took place in the Russian city of Sochi. It is amazing that during its journey, the Olympic flame has visited the deepest lake on Earth–Lake Baikal—Mount Elbrus, and the North Pole. Moreover, the flame went to space.

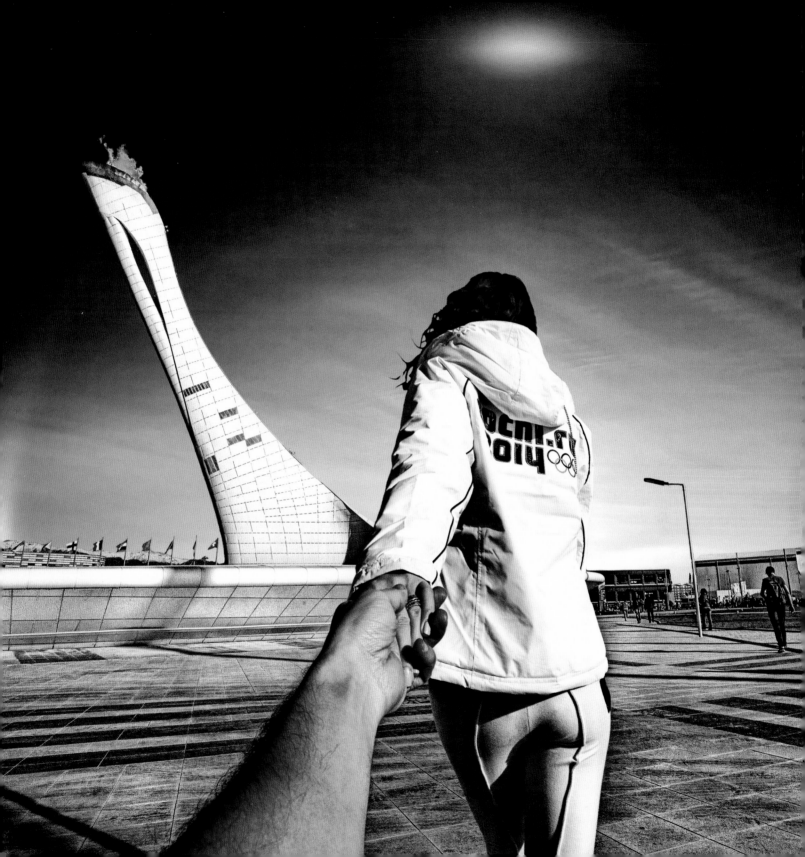

RUSSIA
MOSCOW

Church of the Saviour

Church of the Saviour—the symbol of Orthodox Russia. This temple took forty-four years to build and it can host ten thousand people. Faith can bring light to your soul even in the darkest times.

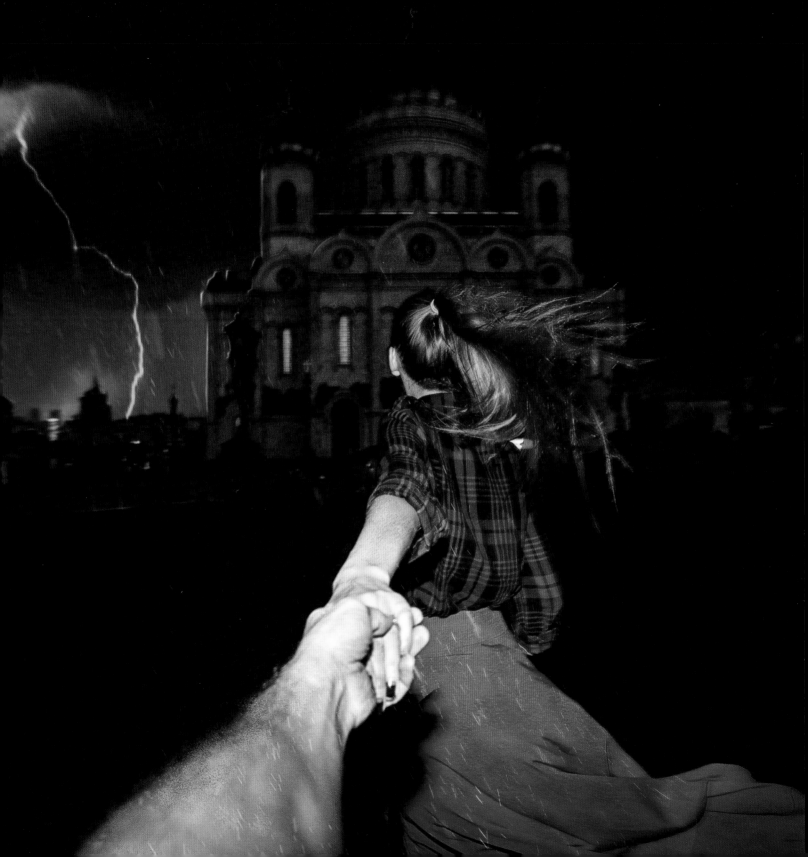

MOSCOW

The Roof

She said yes!

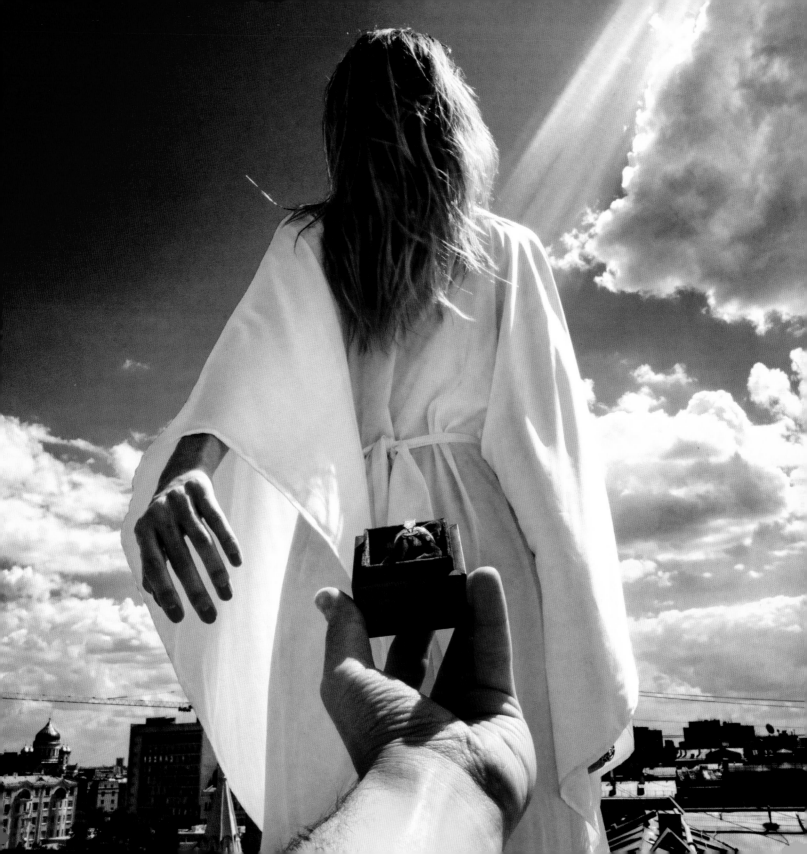

NORTH AMERICA

NEW YORK

The New York Public Library

There's always something mysterious about libraries . . . You can literally see people living their own special stories while reading and studying. It always seemed to me that all the books are about to come alive and start dancing.

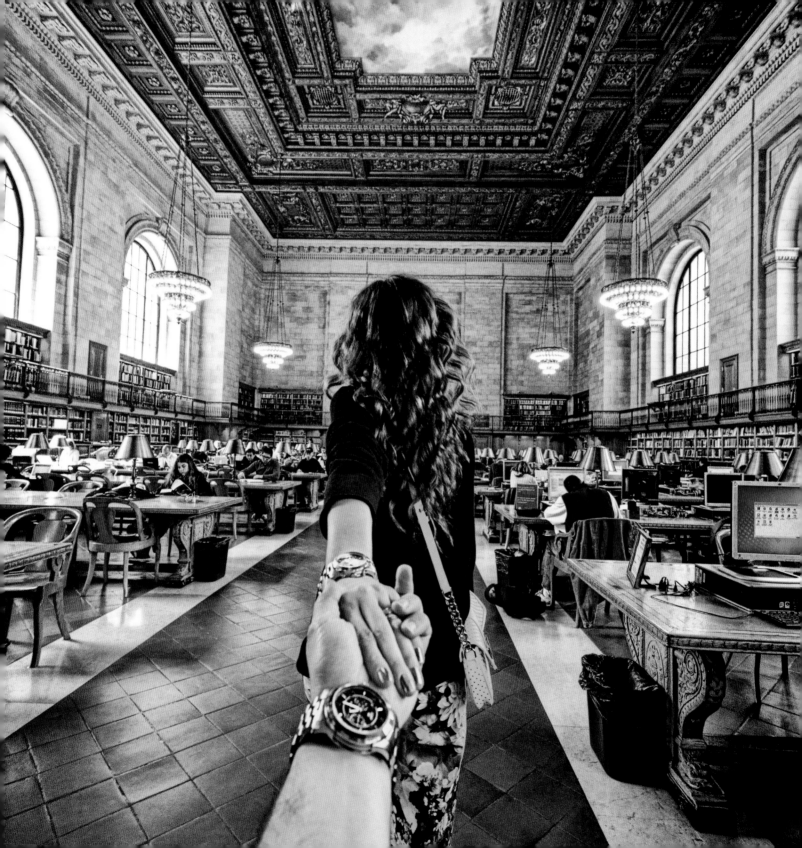

USA
NEW YORK

Mr. Frostee

The famous Mr. Frostee. You can hear the music coming from the truck over three blocks away. Near this truck, even adults are acting like kids.

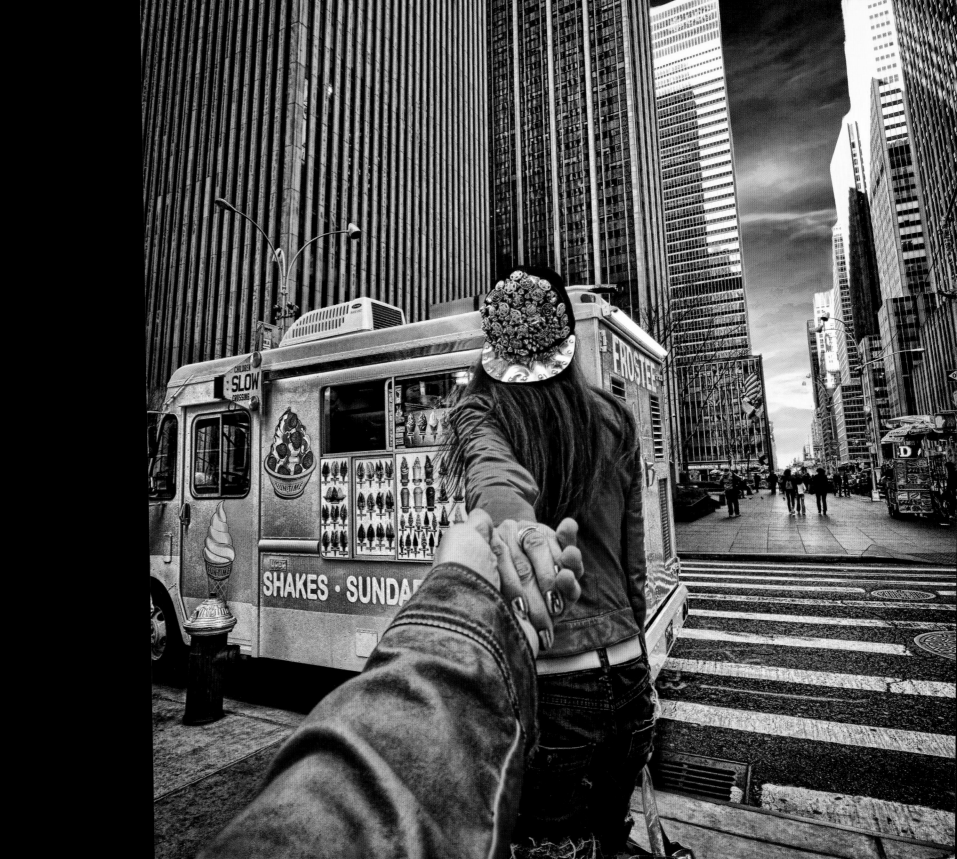

USA
NEW YORK

Times Square

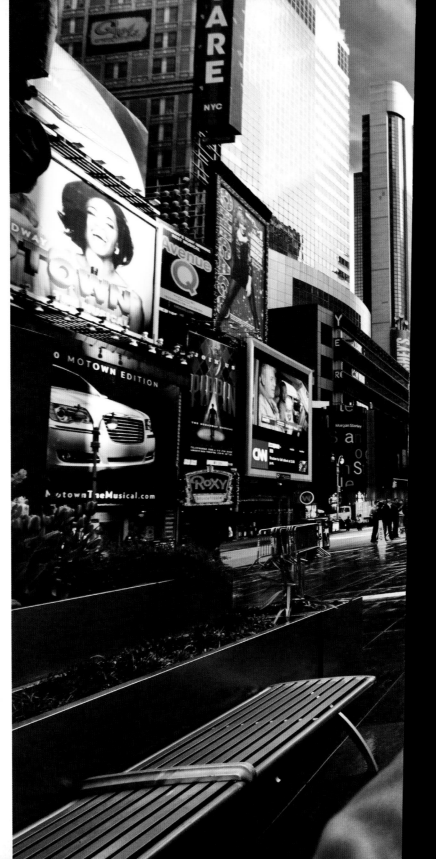

At 6 a.m., the city wakes. After getting a coffee and donning my red carpet dress, I walked around NYC. I recalled the *Breakfast at Tiffany's* movie; people around me were staring, but I only smiled at them, wishing them a good day in my thoughts.

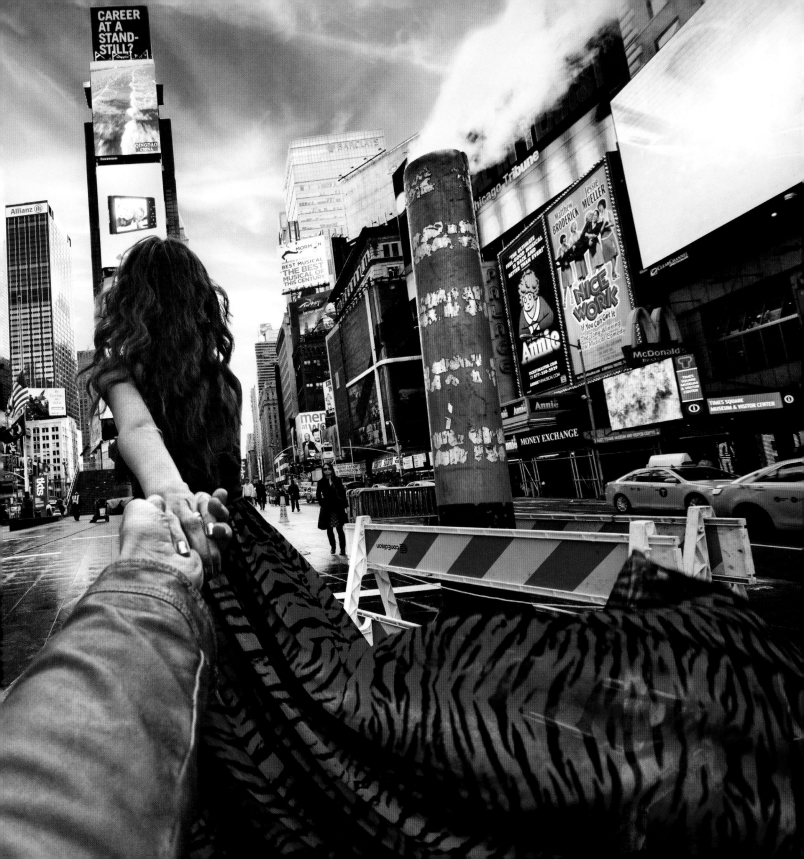

NEW YORK

Central Park

At more than 2.5 miles long (4k m) and covering 843 acres (3.4 km²), Central Park is a New York landmark. And it is not because it is visited by around 25 million people each year, but because the park brings together and accepts absolutely all the citizens of New York. Here, you can find tourists, locals, musicians, couples seeking privacy, large families on picnics, a thin guy with a dog, a lonely elder man wearing a sports suit, a young dad trying to change his baby's diaper, two girlfriends aged seventy all dressed up, a jazzman, sports lovers, and a Russian girl with a laptop writing this story.

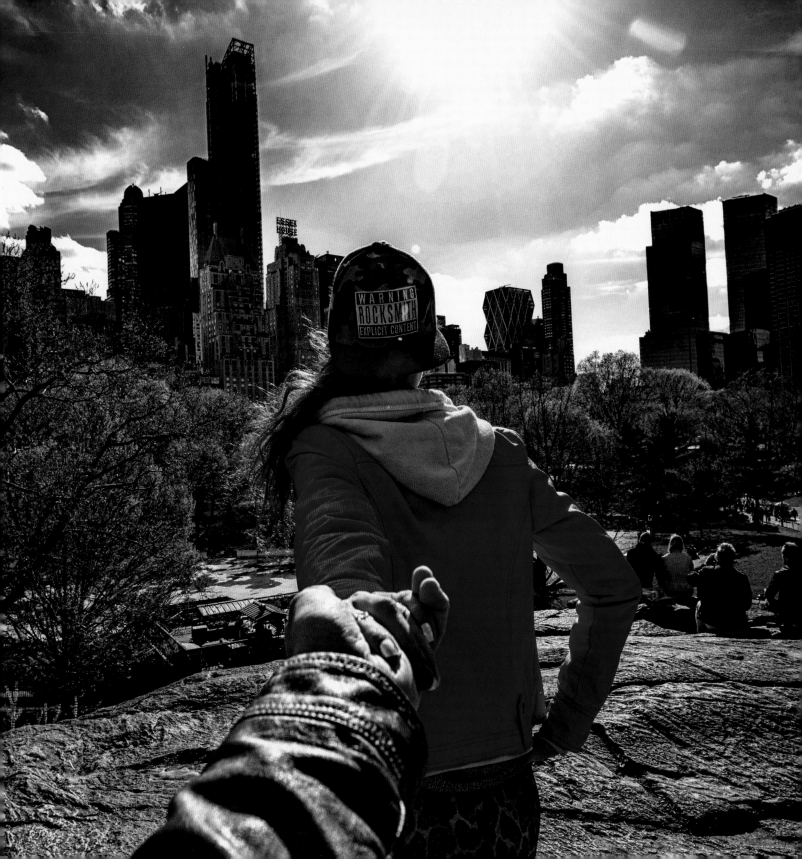

USA
NEW YORK

Brooklyn Bridge

Quite a mysterious place–you are thrilled when you read the story of its construction. It is mandatory to go across this bridge on foot.

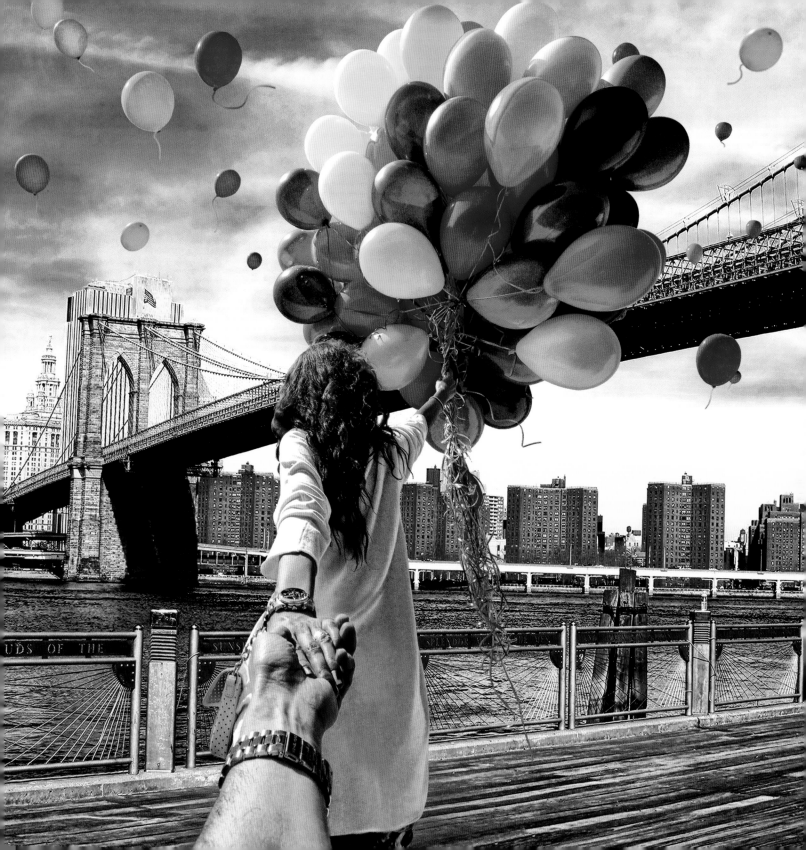

USA
NEW YORK

High Line Park

The High Line Park grows over old railroad tracks, more than thirty-two feet (ten meters) above street level. It is totally New York—fashionable and beautiful.

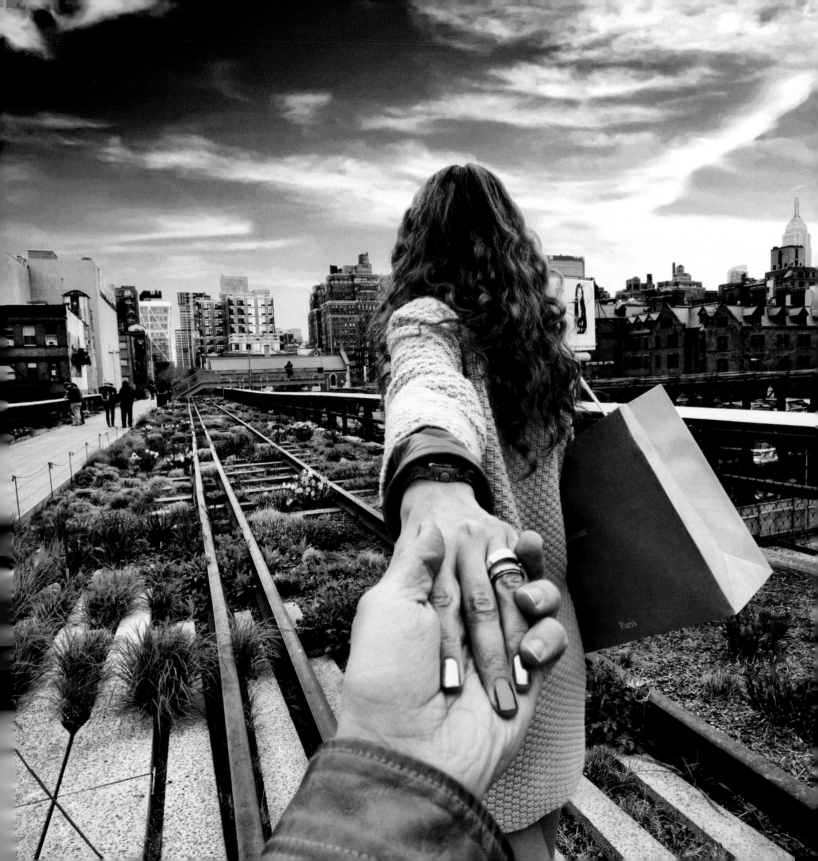

USA
NEW YORK

Brooklyn Bridge

One of the most beautiful, mystical, photogenic, and oldest hanging bridges in the USA! It is such a pleasure to stroll along it and it also offers a perfect view of Manhattan!!!! One of the first places we visited right after our arrival.

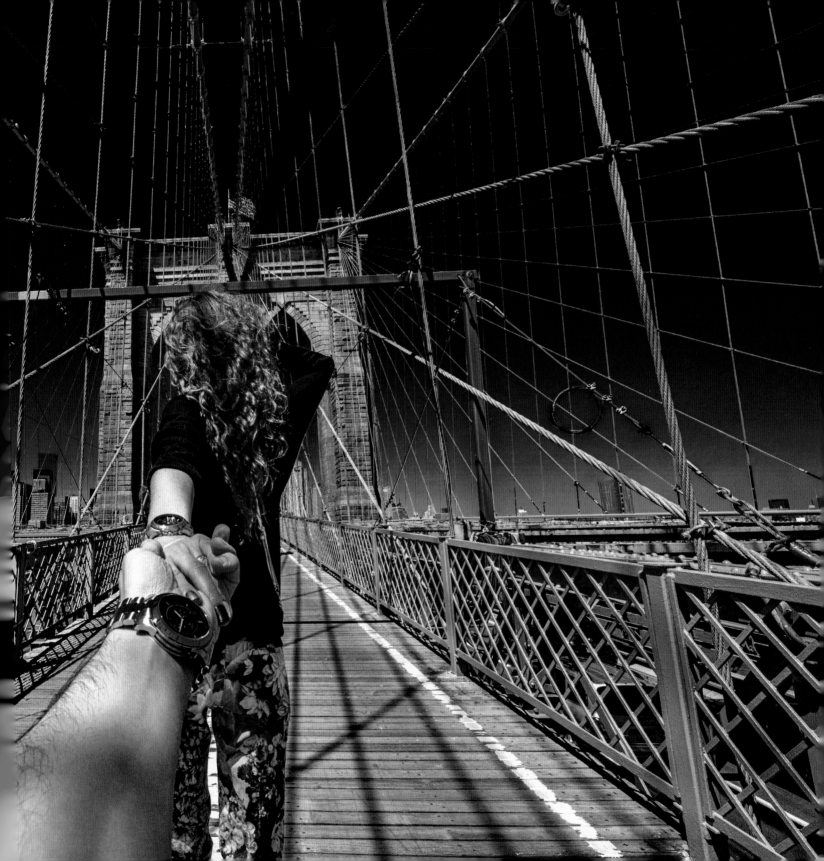

NEW YORK

Bryant Park

Behind one of the largest libraries in the world. When we first got to the library's backyard, we were immersed in this special NYC world. A lot of people with different stories have all gathered here. Some people in suits quickly ran for lunch while others sit with their loves, giggling all day long, staring at the passersby.

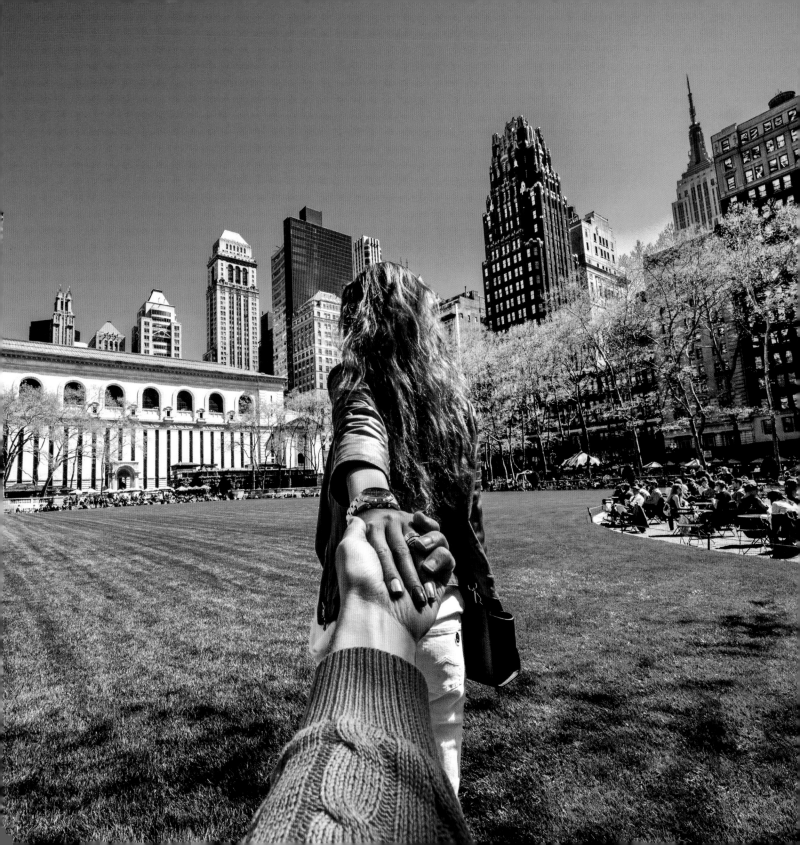

NEW YORK

The Statue of Liberty

The most famous "woman" of the United States. The great symbol in the free America. The statue is located 1.8 miles (3 kilometers) away from the southern part of Manhattan on Liberty island.

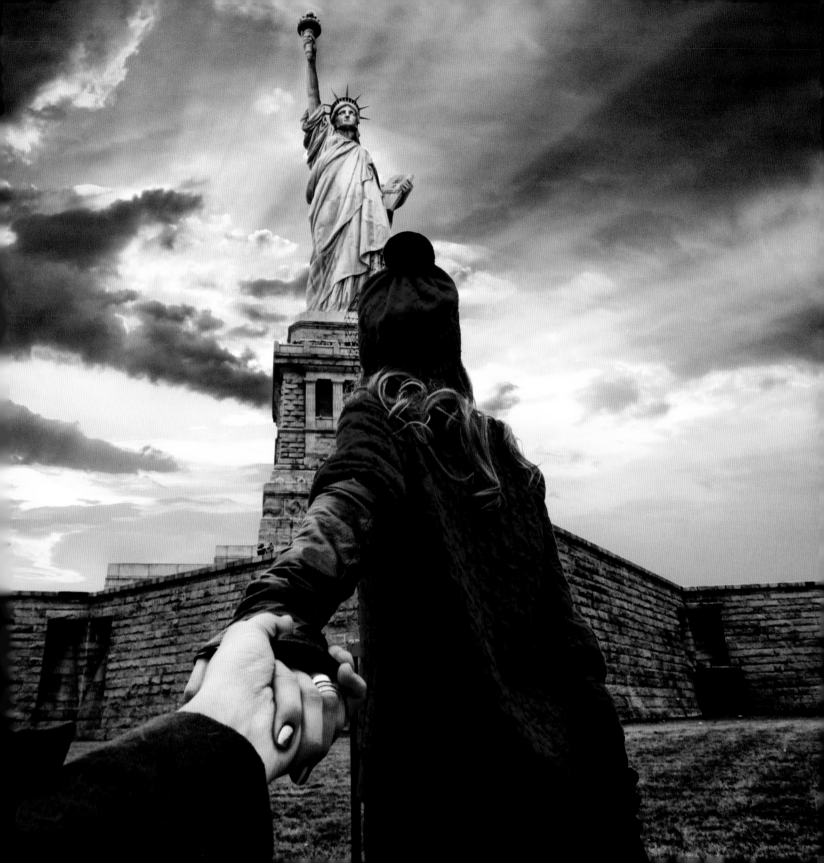

USA
NEW YORK

Yellow Cab

I cannot imagine NYC without its never-ending yellow taxi bugs. Today, 90 percent of the yellow taxis in NYC are fuel-saving hybrid vehicles, thanks to Mayor Michael Bloomberg.

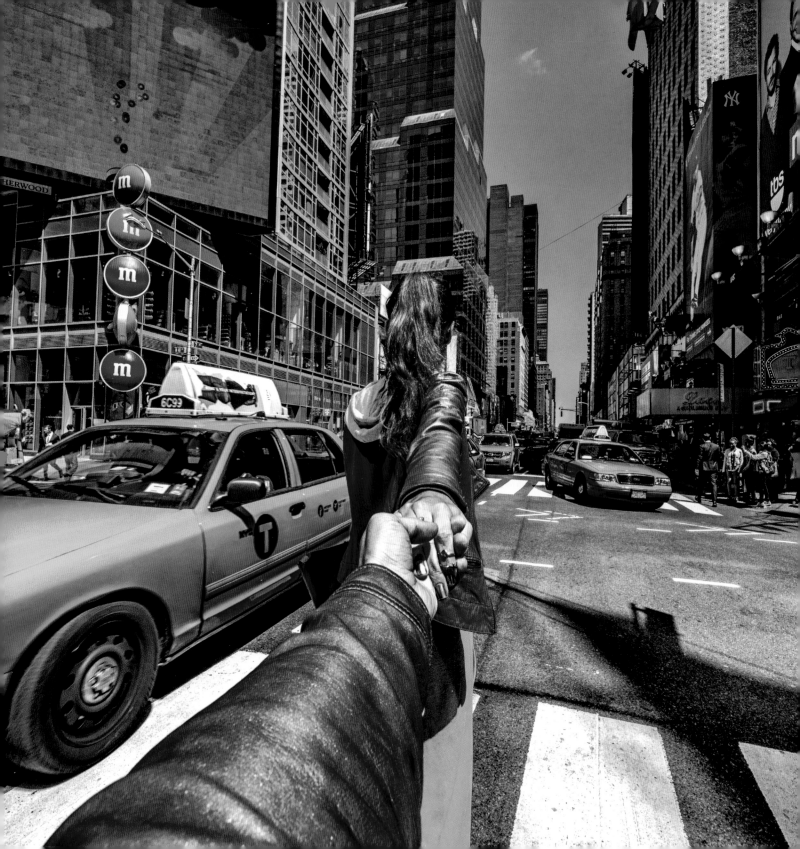

NEW YORK

Laundry NYC

It is amazing that despite the high-tech development, laundries are still quite popular in New York City. They have their own charm. Friends meet here, exchange news, people meet, fall in love, read books . . . it's a whole, distinctive small world.

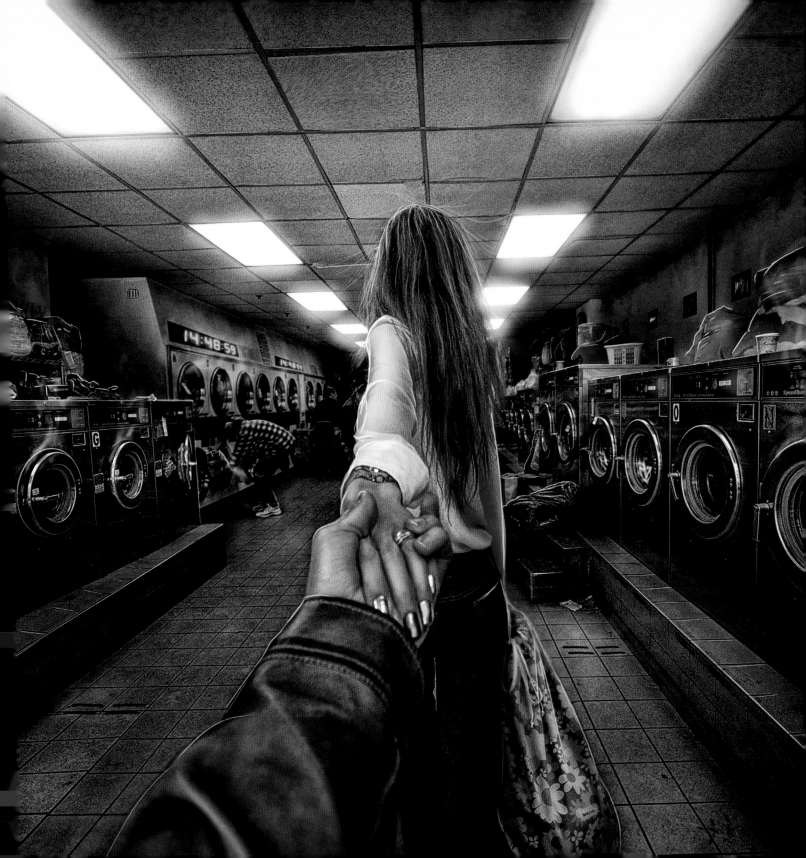

USA
MIAMI

Miami Beach

Of course, the biggest and most famous landmark of Miami is its BEACH!!! Endless space soaked in sunshine, it looks like some fairytale mirage where time stops.

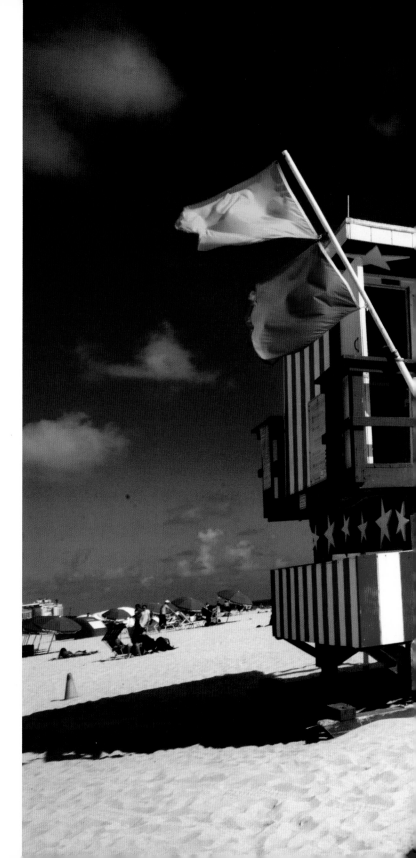

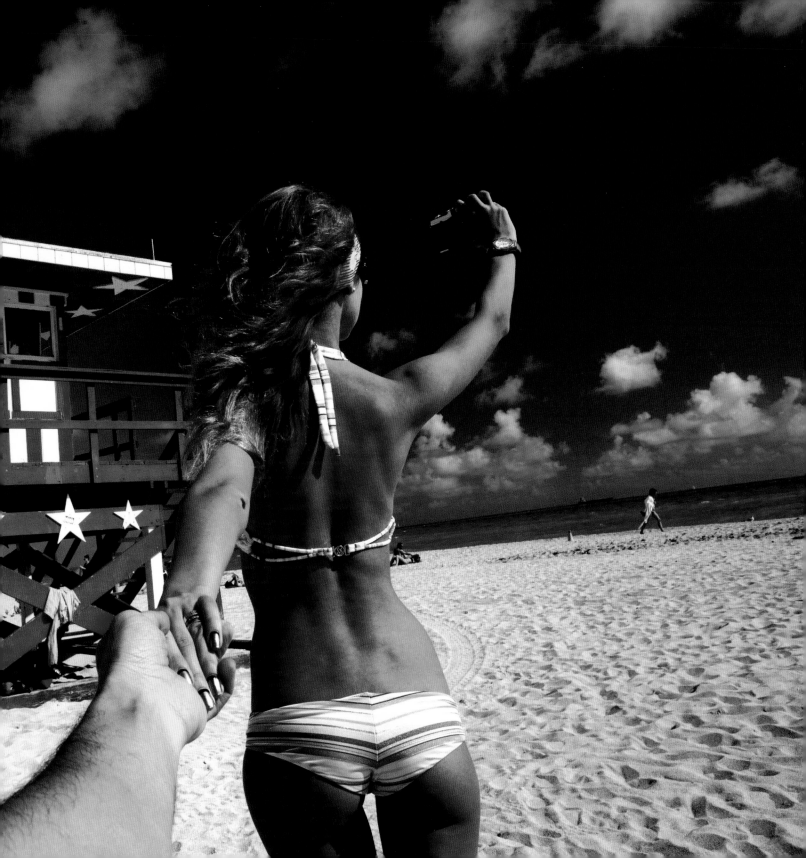

MIAMI

Versace Mansion

A legendary place where the famous maestro Gianni Versace lived, worked, and was killed. Every object here has been touched by the maestro's hand–we were especially impressed with a column hall devoted to continents and people who changed the world and became history.

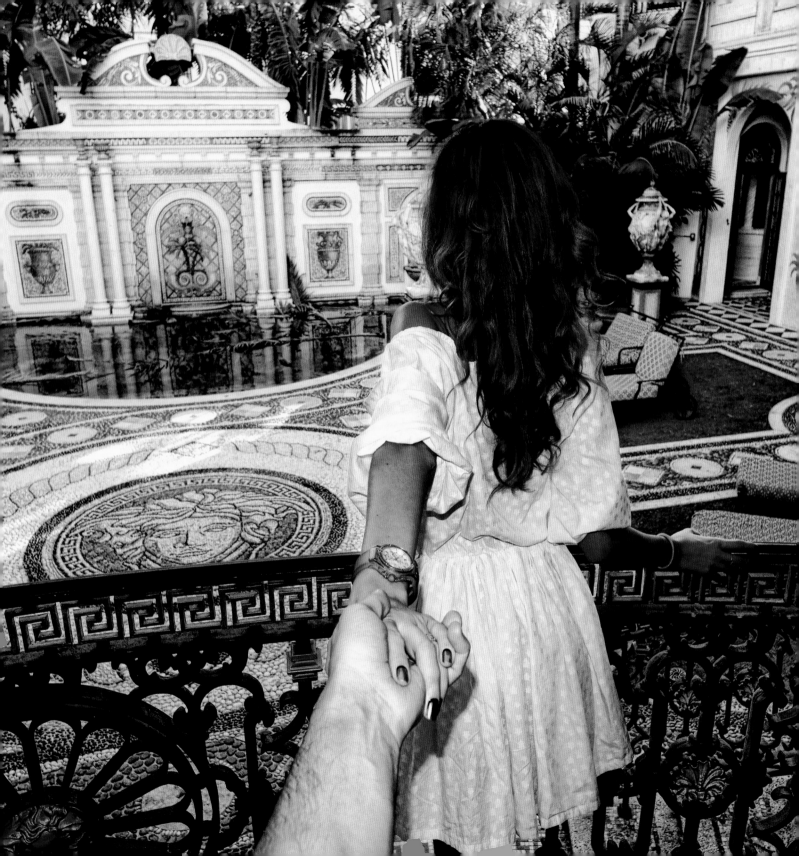

MIAMI

Wynwood Art District

A relatively young but very progressive district in Miami where the most talented graffiti artists turn the boring walls to vivid art every day.

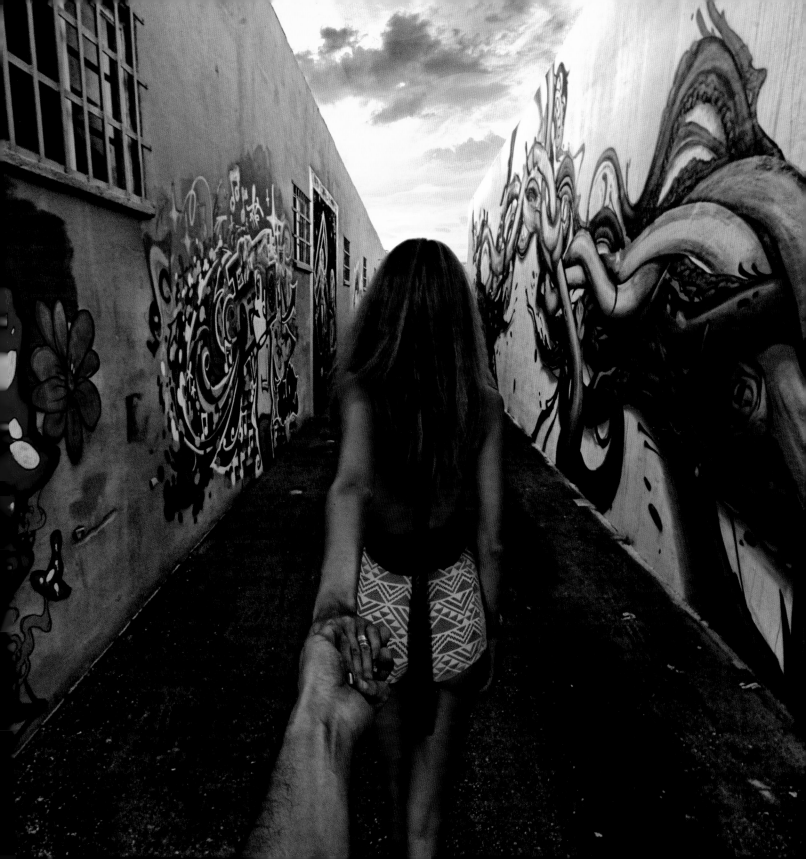

SOUTH
AMERICA

BRAZIL
RIO

*Statue of Christ
the Redeemer*

One of the new world wonders-Jesus-stands on top of the mountain; when we first saw him, we were just stunned. He seems to be protecting Rio, observing everything taking place in the favelas at the bottom of the mountain. He is a popular tourist destination for some people and a beautiful picture for others, but some see him as a symbol of faith-a hope for the best future to come.

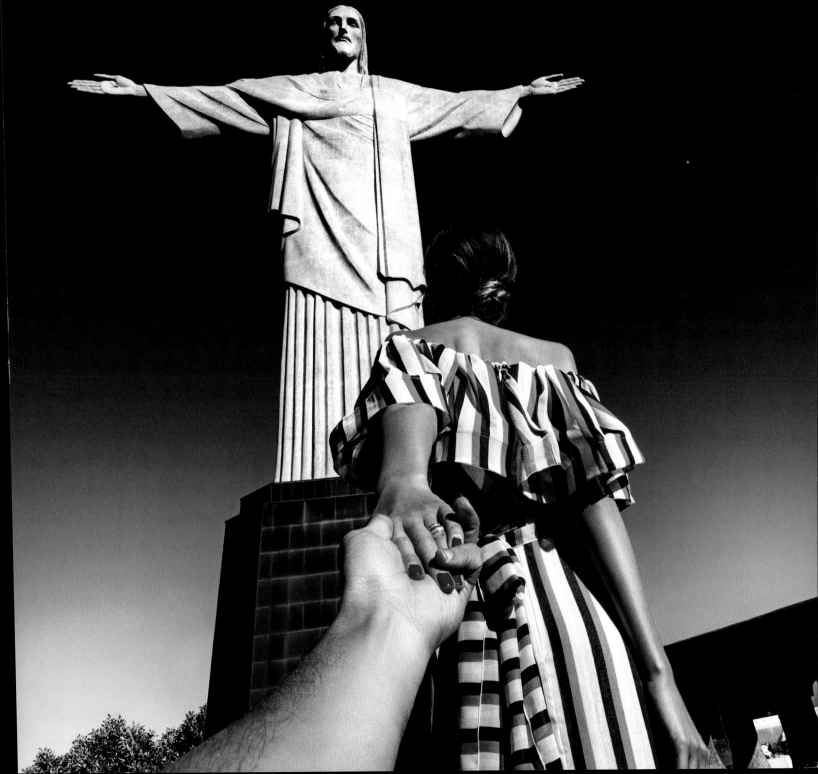

BRAZIL
RIO

Copacabana

The famous Copacabana beach. I have heard so many stories
about it, and we all have seen it many times in the famous
Brazilian TV series. By the way, the black-and-white color of the
asphalt next to the beach is no coincidence–it is a symbol of the
Negro and Amazon rivers, which do not merge for 2 km and
later form a double-colored stream.

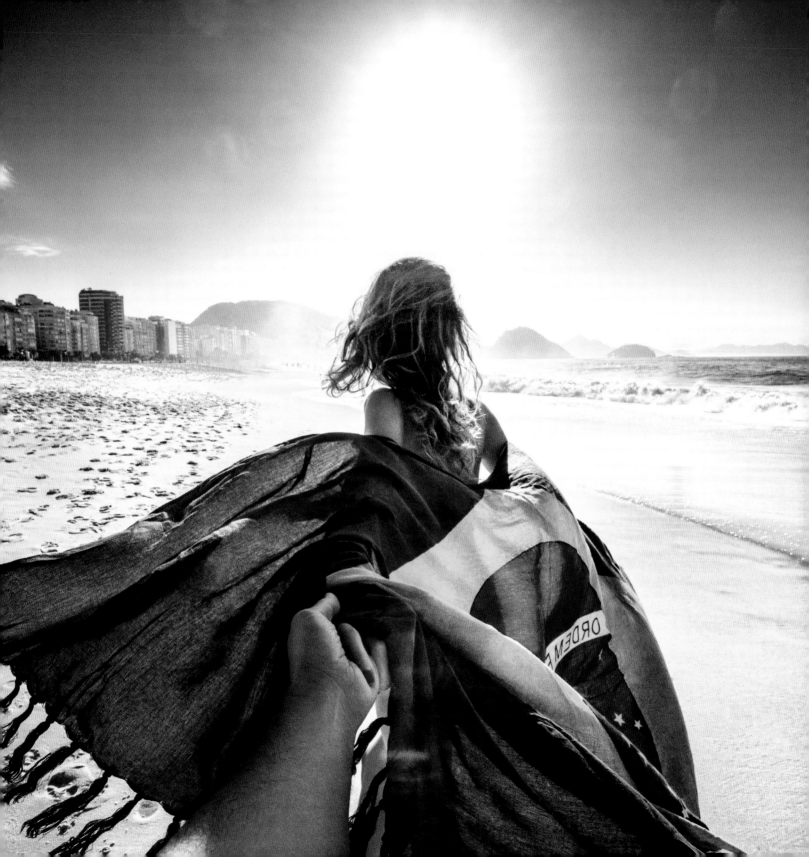

BRAZIL
RIO

Maracanã Stadium

The final game of the World Football Championship, Germany versus: Argentina. What can we say? Emotions rose higher than 100 degrees Fahrenheit. Tears, laughter, screams, disappointment–all this is mixed here and spiced up with beautiful professional soccer.

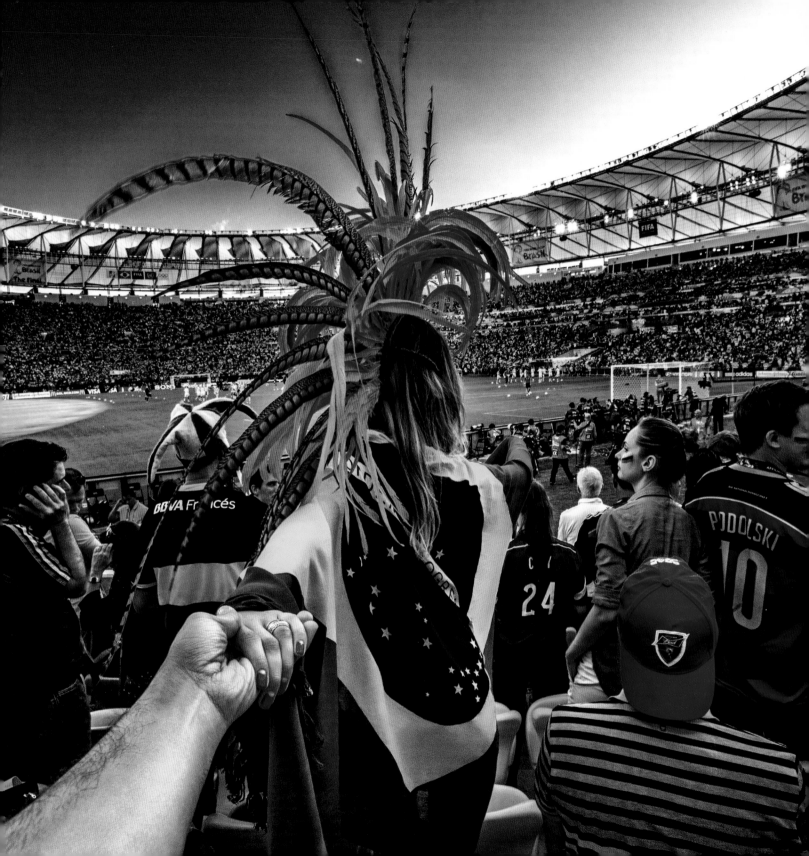

BRAZIL
RIO

Dois Irmãos

It took us around an hour to climb this mountain-we ruined
our legs, met some monkeys, and other tourists as crazy as us.
But when we reached the goal and saw the landscape, we forgot
how tired we were-the time just stops here.

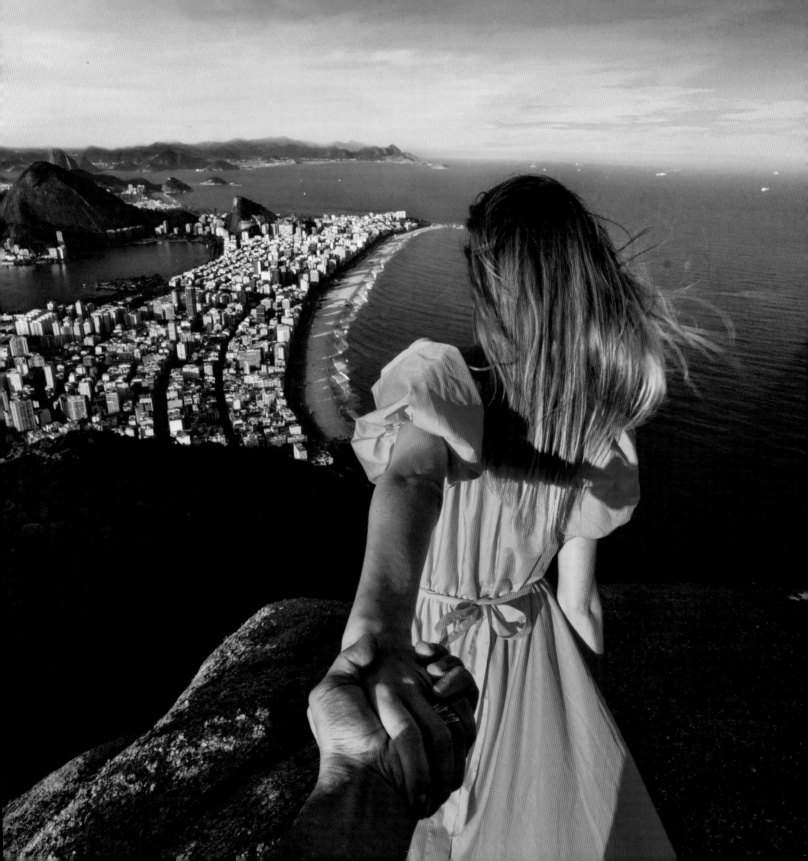

ASIA

JORDAN

The Dead Sea

The saltiest water basin on Earth, situated 400 m below sea level. Total silence, glittering salt crystals that lie quietly, solemnly observing all the guests. It is amazing that a place where there is no life acts as a natural healing center for people!

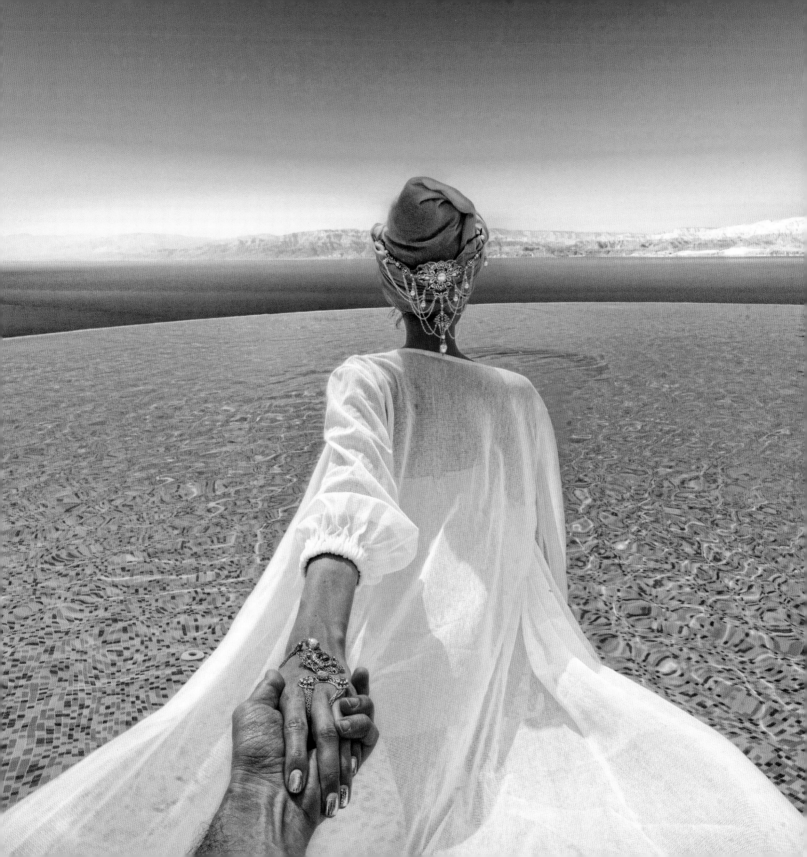

JORDAN
DESERT

Bedouin Camp

Many Bedouins live in the Wadi Ram deserts. Many family tents stand in small groups far from civilization. We were very lucky to stay in one of those places. It is a place of desperate soul searching.

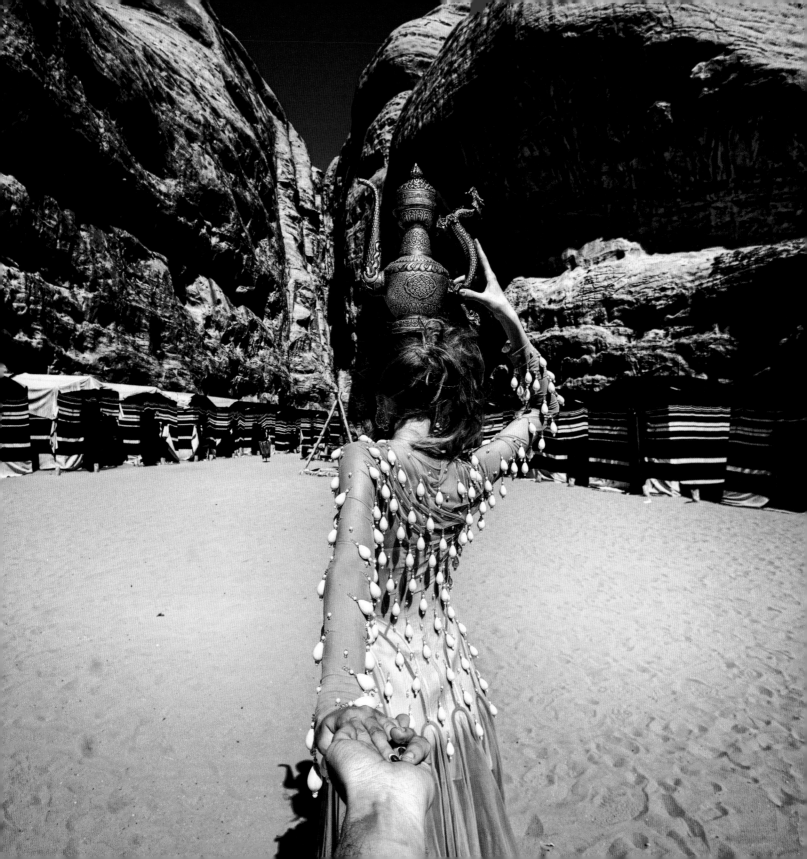

JORDAN
PETRA

Petra Treasury

One of the world's wonders. Perhaps the most mystical place of Jordan, full of legends and stories. It is also called the Rose-Red City. You can visit it at night and during the day–our advice is to stroll along the gorge twice, as the feelings are totally different. This is the place where the Nabatean Kingdom used to be (third century BC to second century BC). Before the twentieth century, the local people used to live in cave houses made in pink sandstone cliffs.

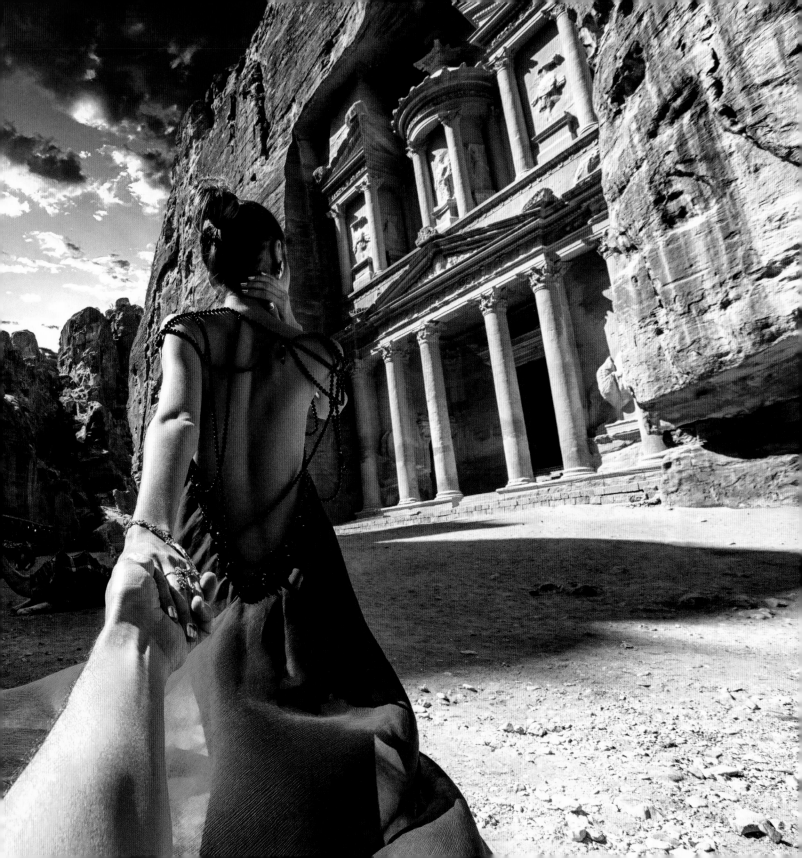

JORDAN
MADABA

Moses Mountain

The Holy Land of Jordan and Israel. We climbed up the Sky Mountain (translated as the Prophet Mountain)—it is here that Moses is buried and where, after forty years of wandering, Moses showed his people the Promise Land.

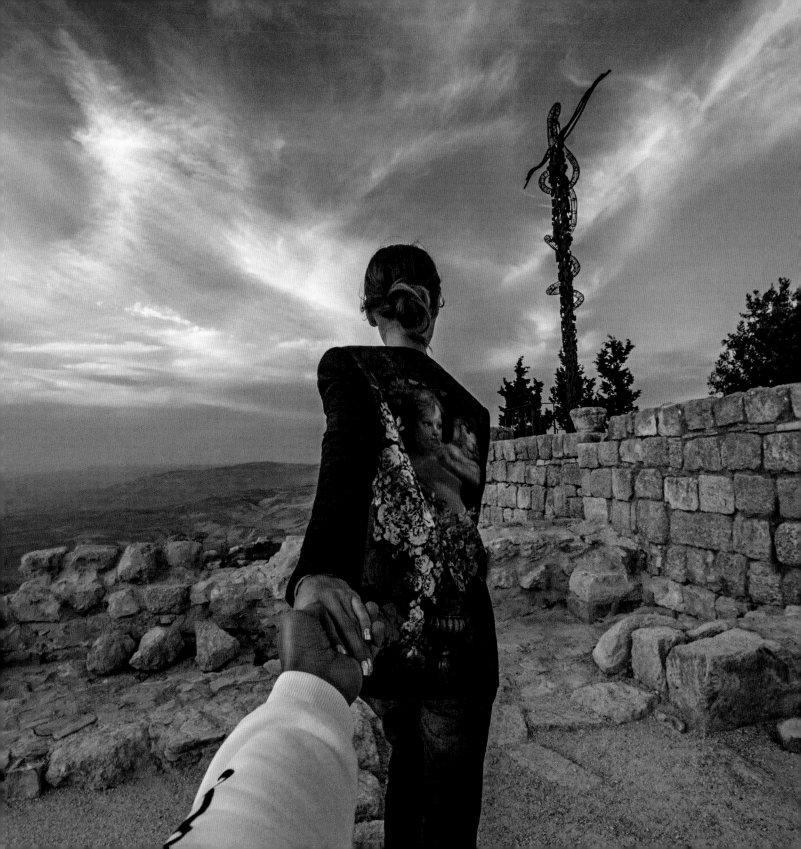

THE JORDAN DESERT

Wadi Rum Desert

Flying above the Jordan desert, you realize how beautiful our world is and how small the people are with all their worries and problems. When back at Wadi Rum, we were stunned by the fact that schools and hospitals existed even in the most remote and lost desert districts of Jordan and in the most authentic communities with none of the facilities that we are used to, where people live in tents. These establishments were everywhere!

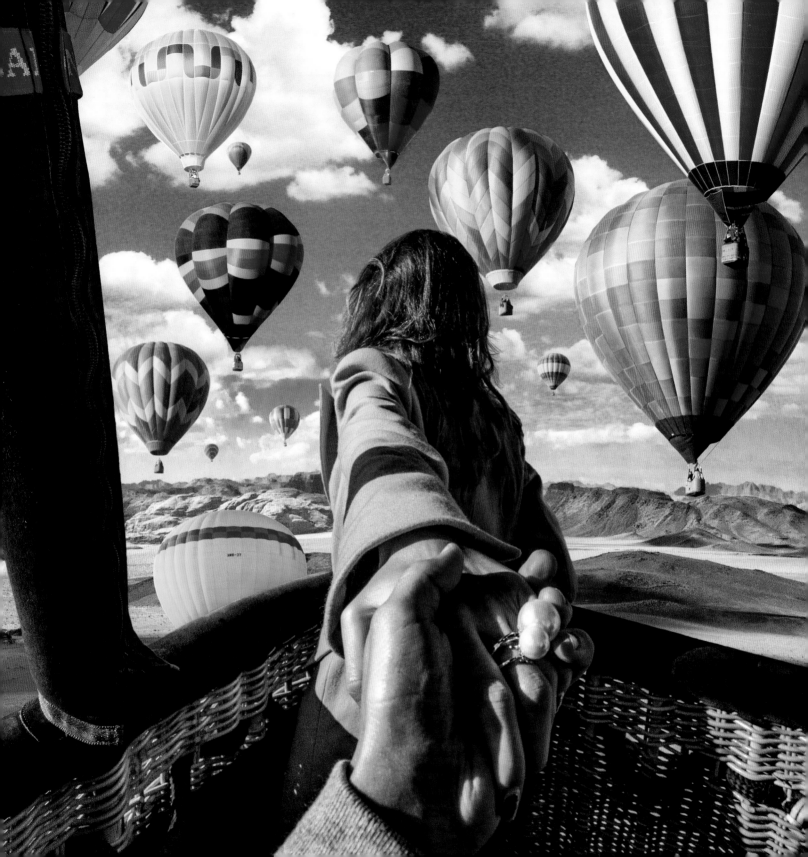

JORDAN
AMMAN

Amman Citadel

A very special place right in the middle of Amman. When you are on top and look around, it seems like you can literally touch the heritage of the Greek, Roman, and Ottoman Empires, which is everywhere around you, as each of those marvelous epochs has left its distinctive architecture here.

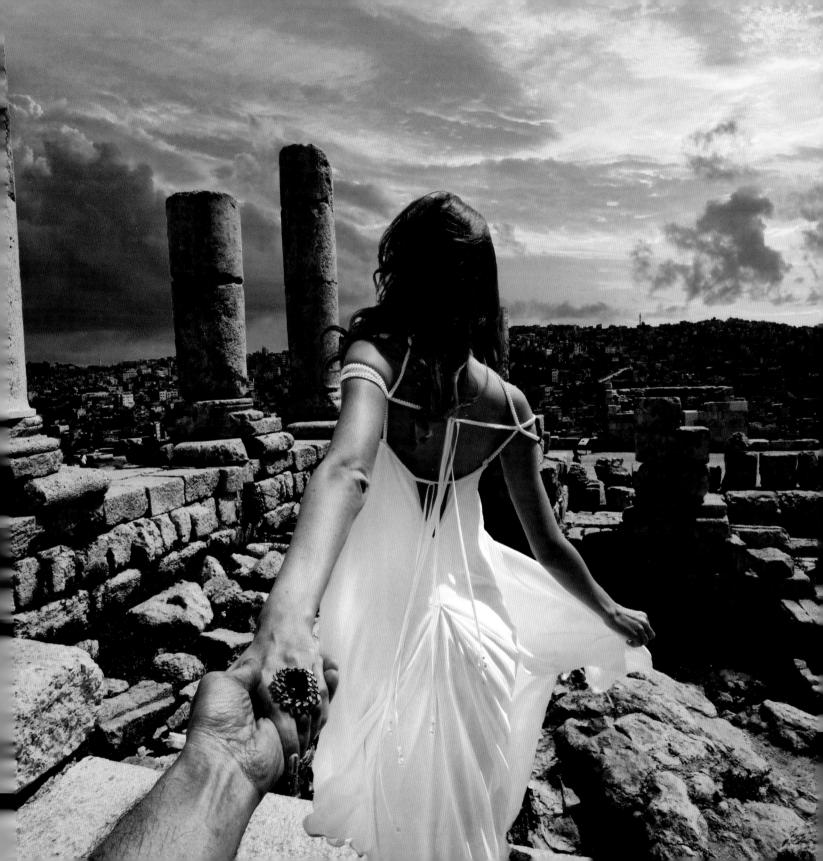

JORDAN
PETRA

Monastery

You just can't believe your eyes when you see it. First, you pass through the Treasury (the most famous monument), carved into the red rock face. Then you have to go through a gorge with natural walls that are 60 meters high. Then we decided to ride donkeys to get to the monastery. The 800 steps and 5 kilometers of riding were not easy.

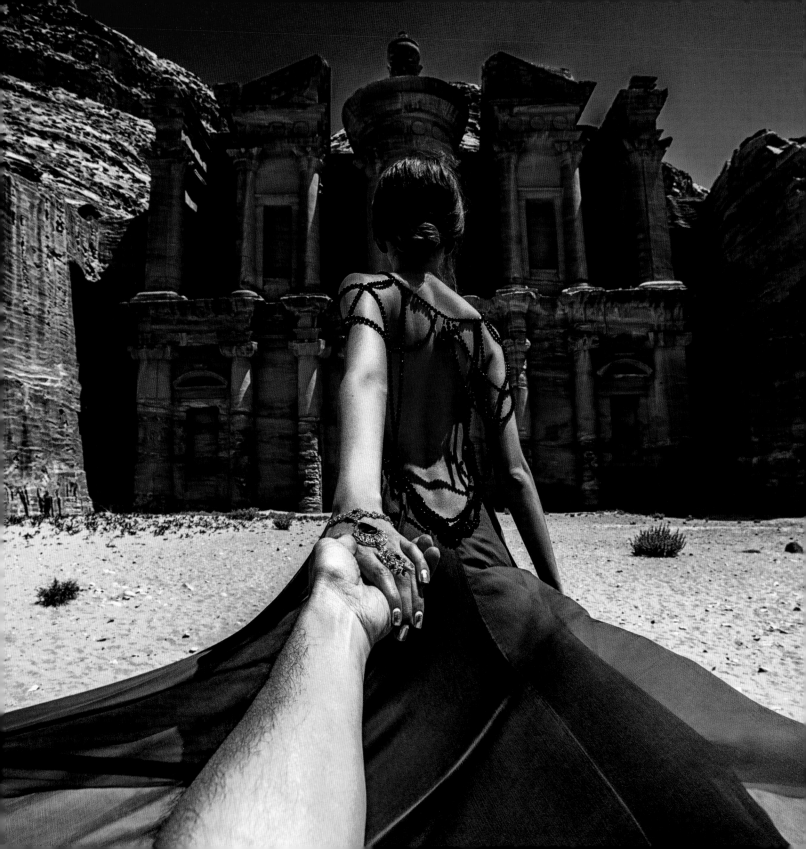

AZERBAIJAN
BAKU

Maiden Tower

There are many legends surrounding the construction and the naming of the "Maiden Tower." One of the most popular Turkish legends involves an emperor who tried to protect his daughter from a prophesy that she would die from the bite of a venomous snake.

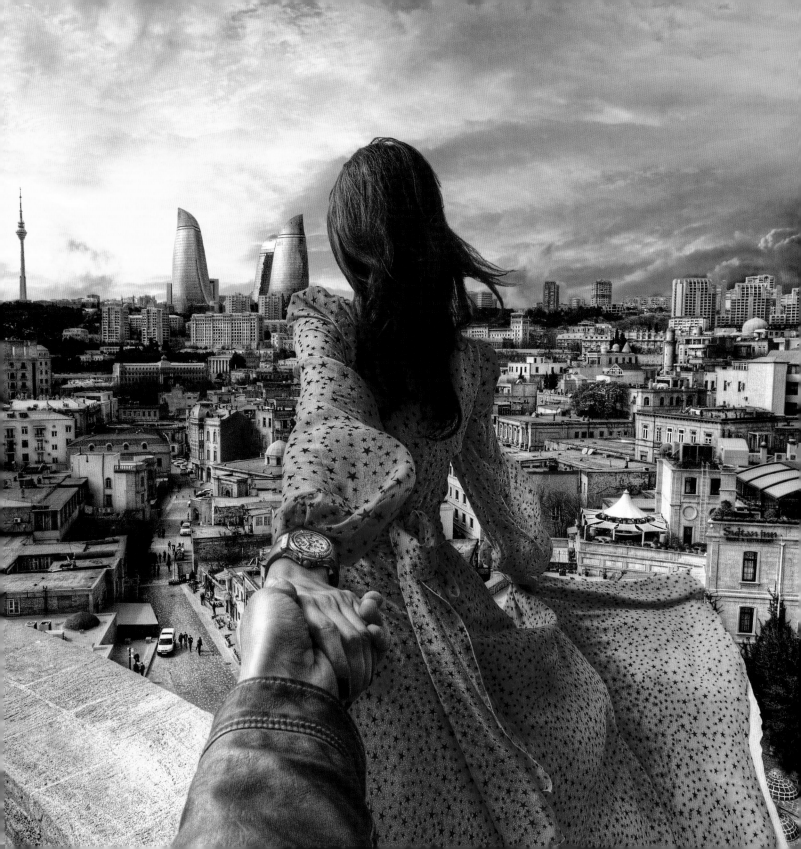

BAKU

Old Town

It is amazing that such yards are called "Italian" in Baku! And they still exist—beyond time, beyond civilization, they are so cute and cozy.

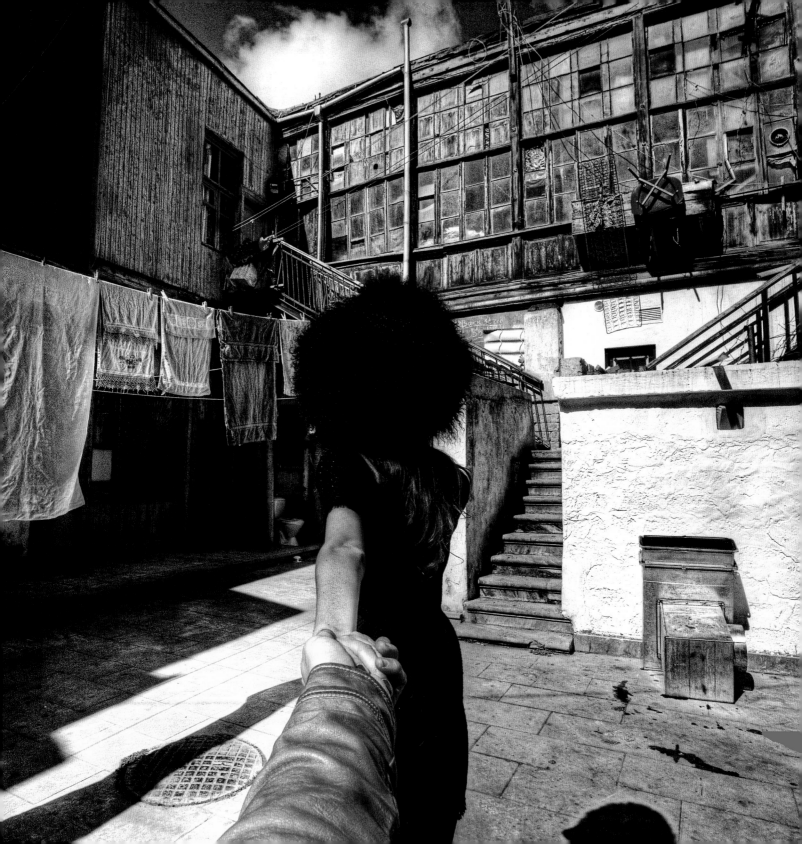

AZERBAIJAN
BAKU

Heydar Aliyev Centre

The symbol of modern Baku named after
the third president of Azerbaijan Heydar Aliev.
Baku is not only an architecturally ancient and
ethnic city—today it is modern and developed.
A city where you wish to return.

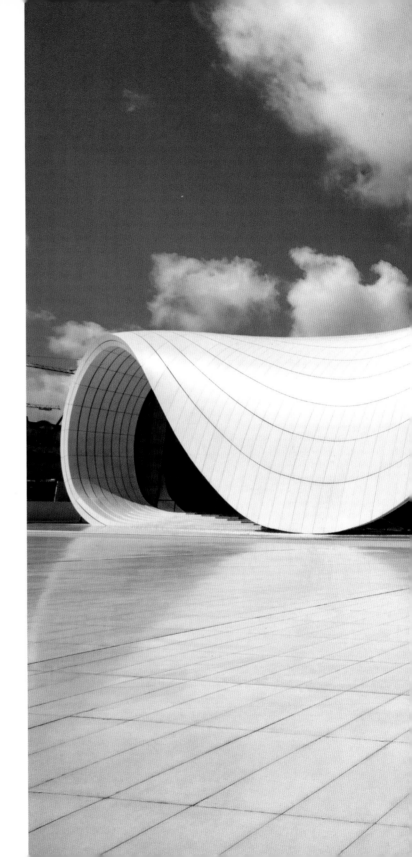

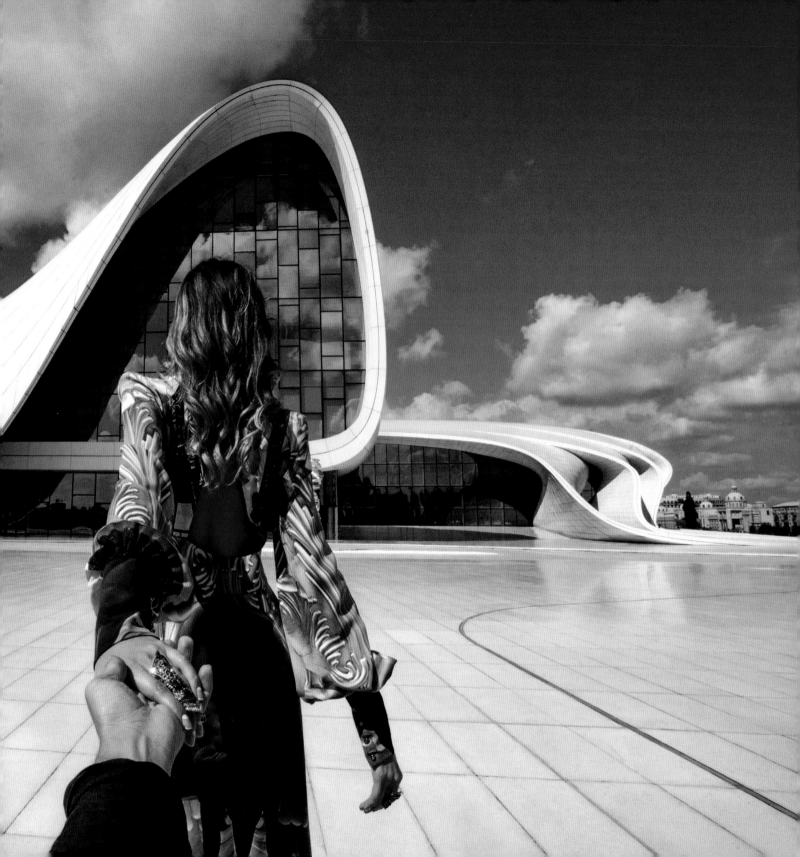

UNITED ARAB EMIRATES
DUBAI

Helicopter

The rooftop of the most famous Dubai hotel hosts a helicopter
spot that offers magnificent views of all the "gold" of the
Emirate: the palm made of islands and the highest building
on Earth. Behind me there is a new project: islands
forming continents!

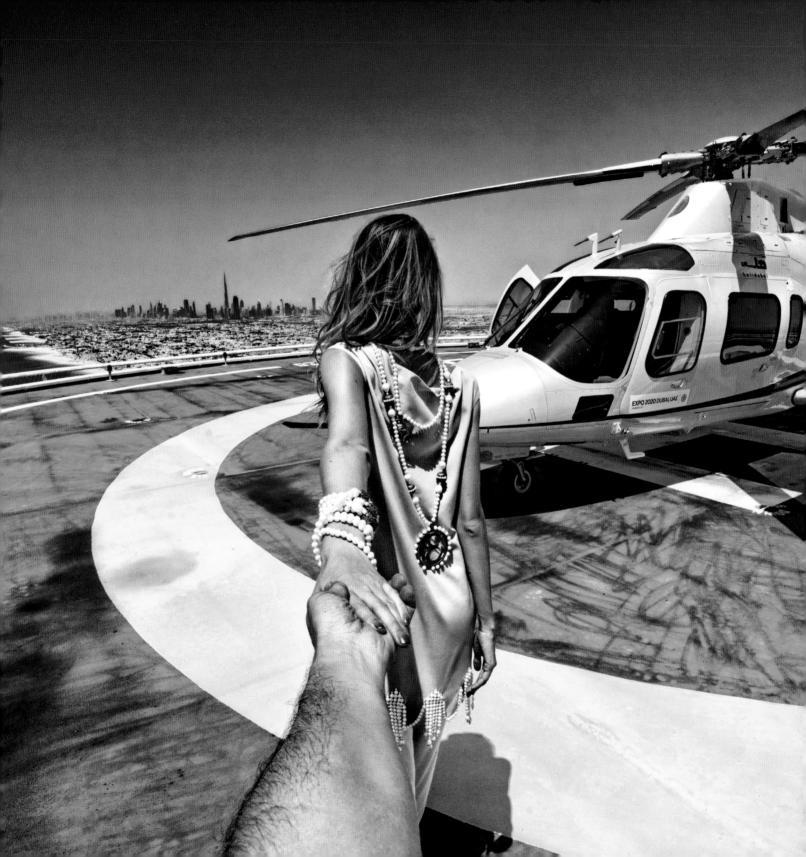

UNITED ARAB EMIRATES
DUBAI

Desert

One-hundred thirteen degrees Farenheit is not the hottest weather in such places. The wind does not let you open your eyes and you are left tete-a-tete with your thoughts. There is a hawk on my arm–it is considered to be one of the fastest raptorial birds in the world.

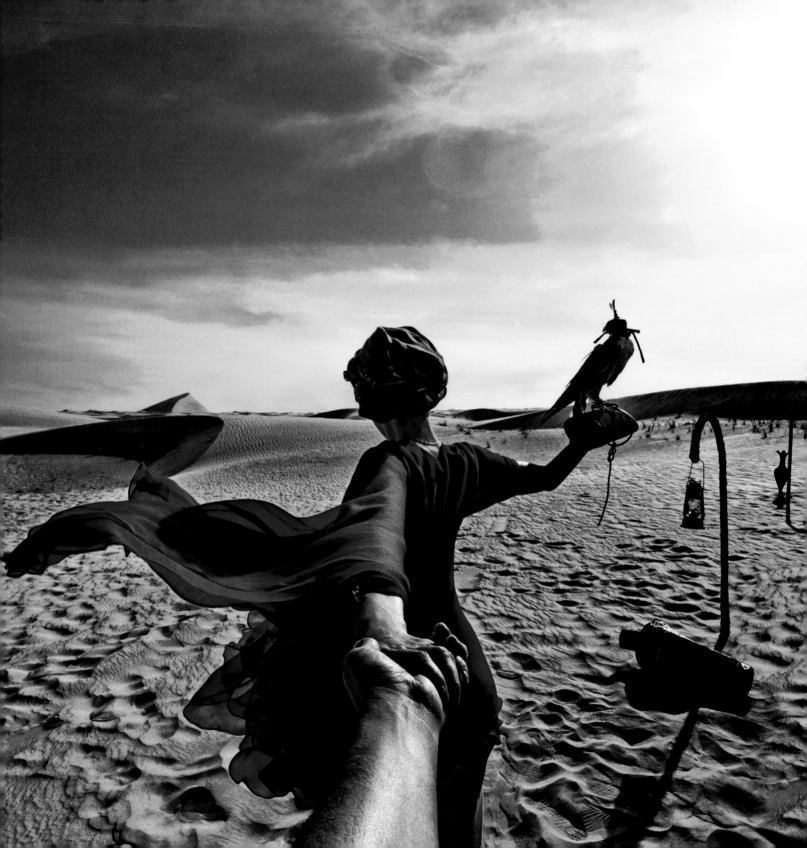

UNITED ARAB EMIRATES
DUBAI

Burj Al Arab

Dubai is the youngest megapolis in the world. The city is stretched along the coast and has the longest (around 80 km) shore line in the world. Dubai's beaches are some of the cleanest and whitest on Earth.

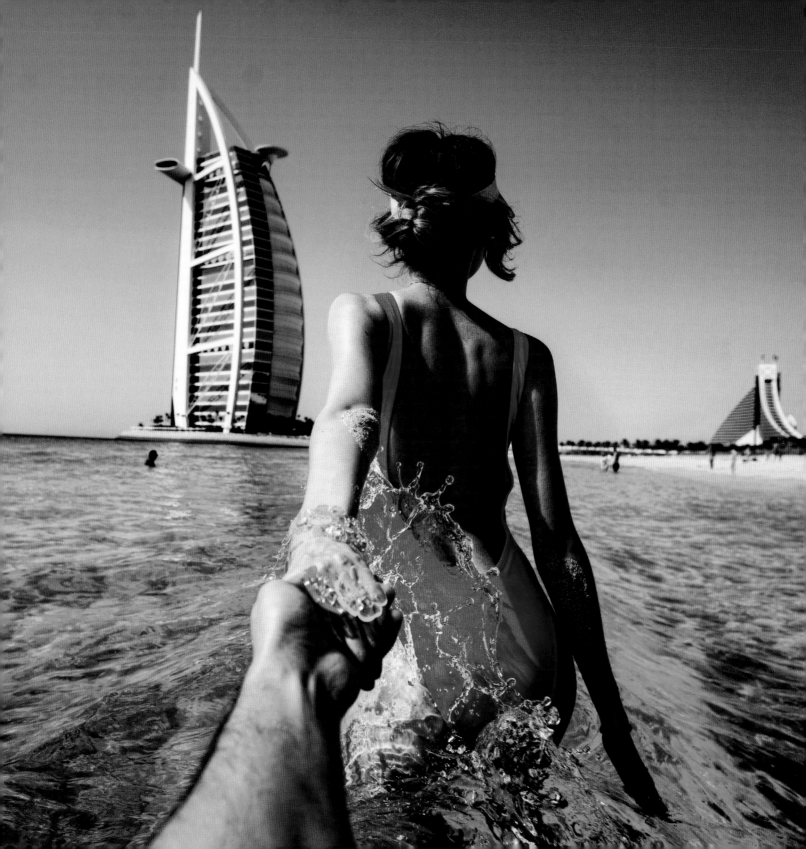

CHINA
HONG KONG

The Tram

The crazy megapolis pace of life—split mind and total indifference to everything that is around you. That is how we were running from one station to another to make a nice picture.

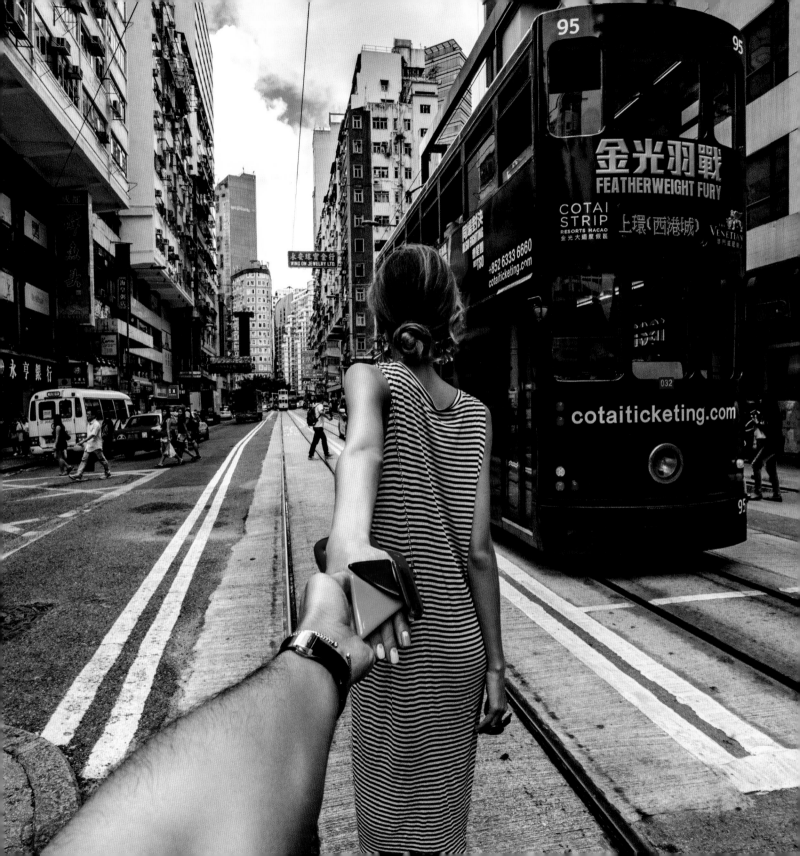

CHINA
HONG KONG

Big Buddha

A magical place—we came here to shoot twice and both times, due to mysterious forces, we weren't able to properly capture the sheer enormity of the Big Buddah! There are endless stairs here that make this place look even more enigmatic.

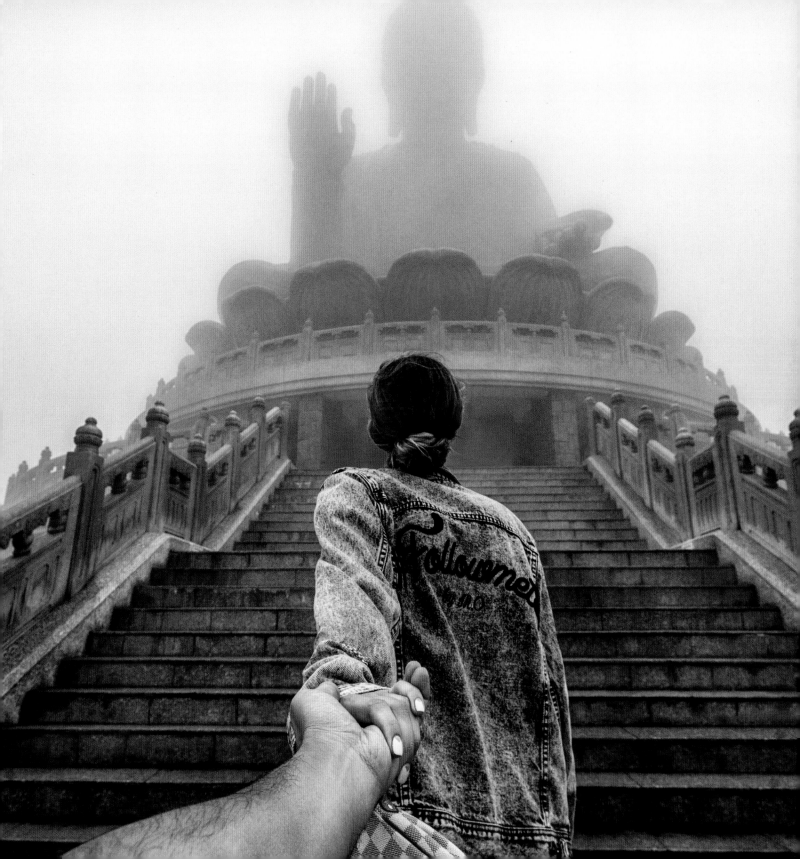

CHINA
HONG KONG

Victoria Peak

Let me reveal a secret: it is here that I first told Murad that I love him. Here, you feel higher than the clouds both literally and metaphorically as when it is cloudy, you can touch the clouds with your hands.

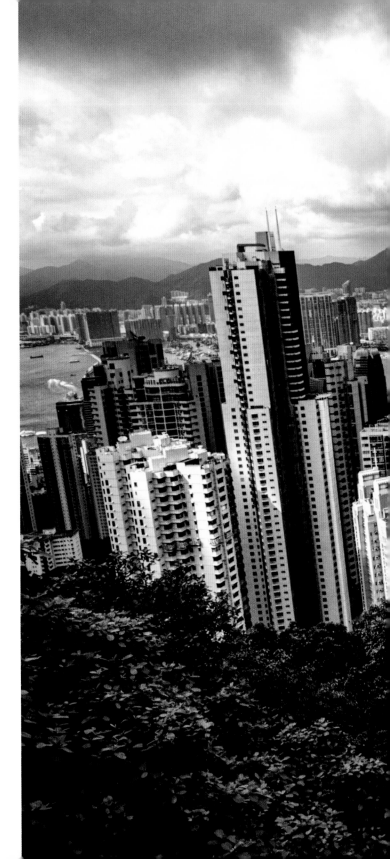

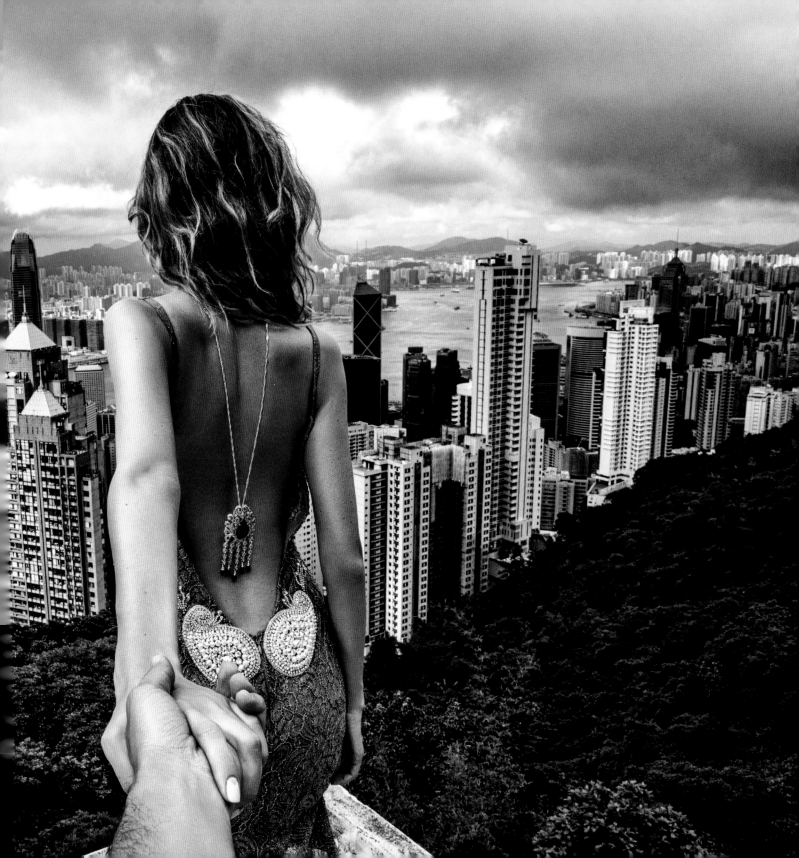

CHINA
HONG KONG

The National Park

The dam in the National Park. This place is considered to be the largest park in China. There are no people here, and it is so quiet that you seem to be on another planet.

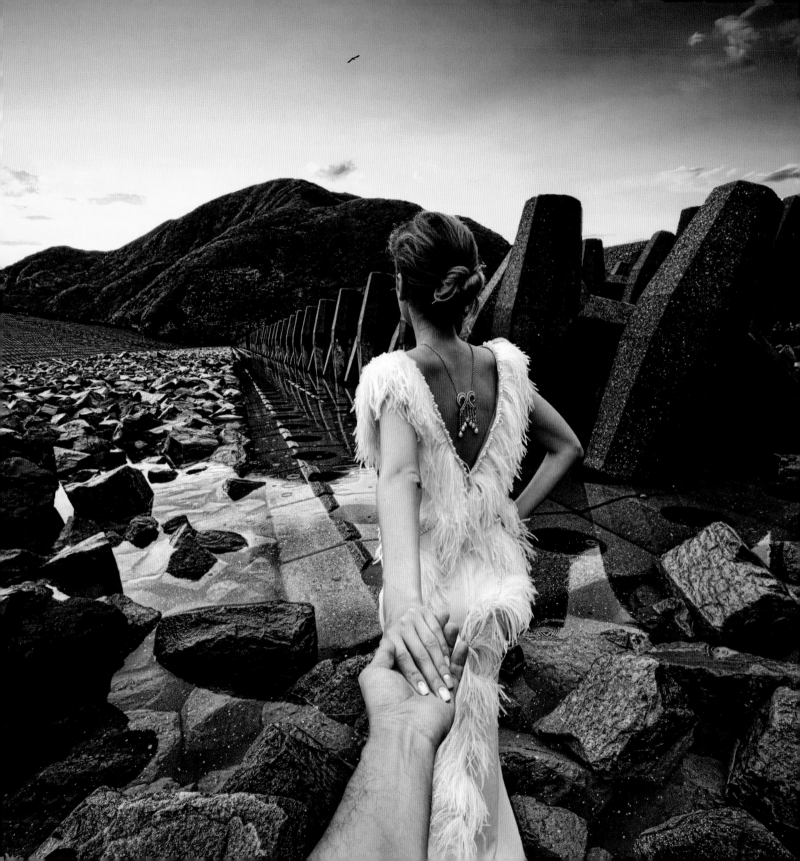

CHINA
HONG KONG

Panda Park

All the pandas in the world belong to China. In fact, this cute animal has actually become a symbol of the Celestial Empire and their friendship. We took part in helping prepare the global campaign in Hong Kong, which involved 1,600 paper-mache pandas.

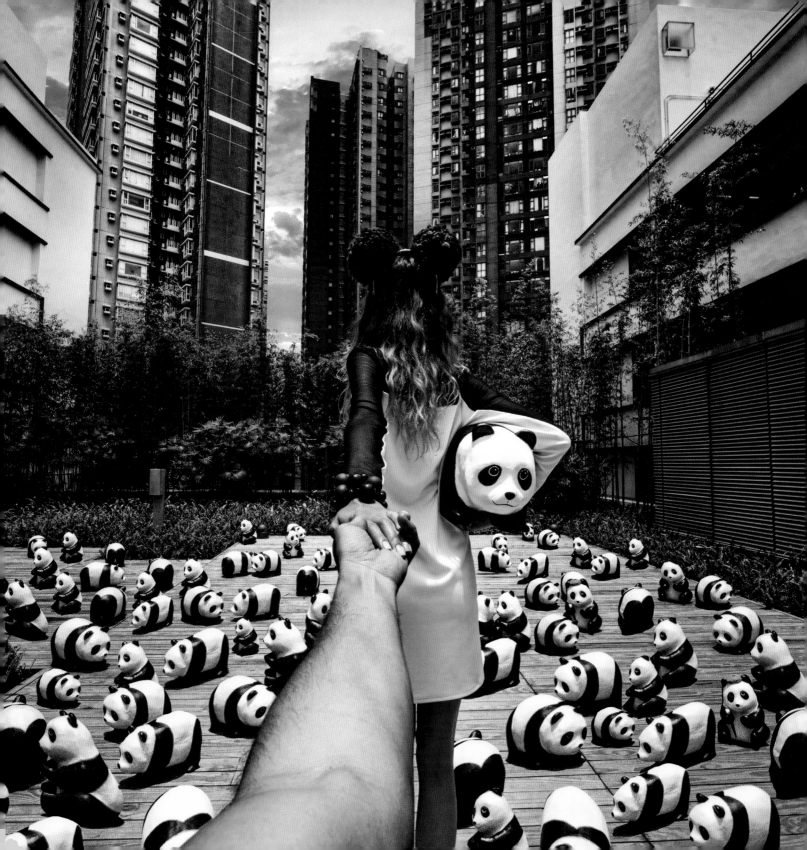

HONG KONG

Jonka

Jonka boat is a traditional Chinese boat. With its scarlet sails, it takes excited tourists on a ride between the two coasts. What can be more romantic than the sea, a boat, and your loved one? The seaside romance . . .

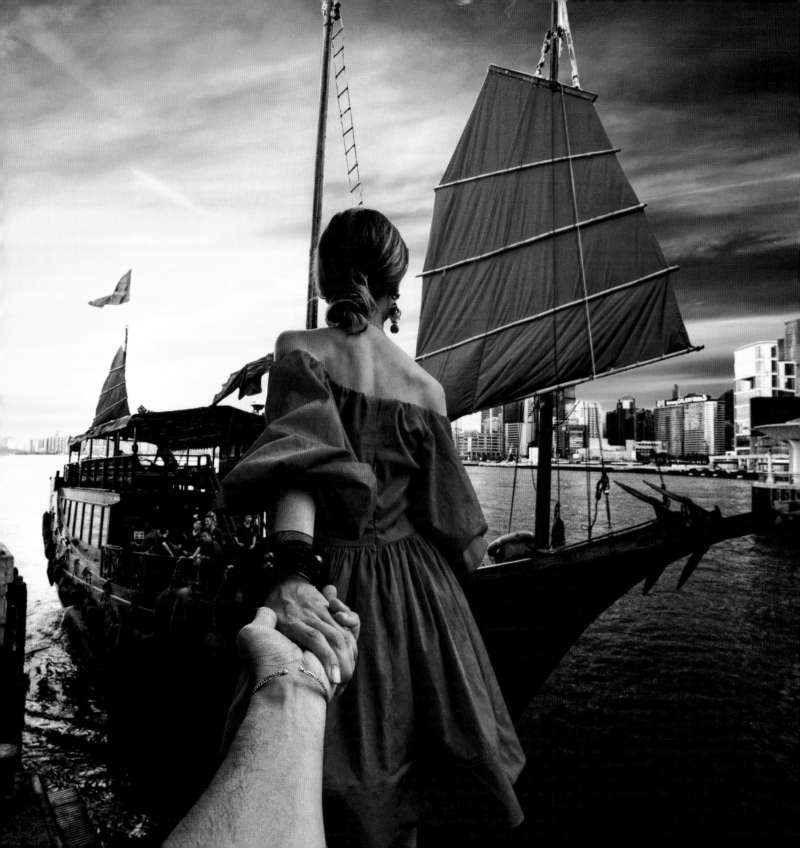

CHINA
HONG KONG

Journalists

We were riding an old double-decker tram that offered amazing views of the Hong Kong streets. You can see journalists and what actually happens behind the curtain.

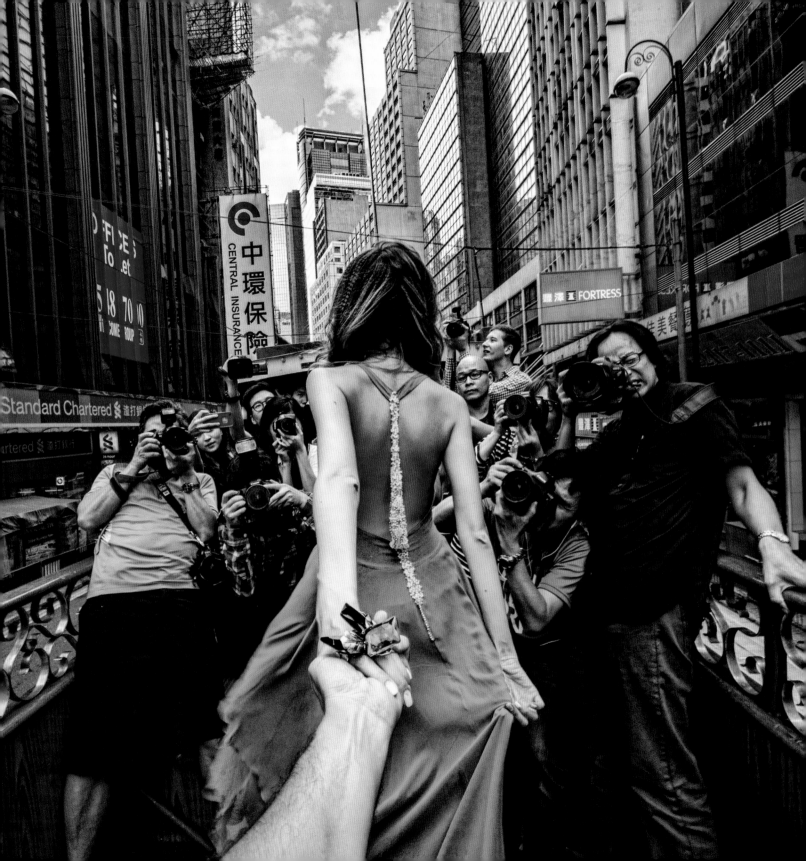

HONG KONG

Disneyland

When entering Disneyland, you forget your age—you long for sweets and balloons and you just have to ride all the rides! We are all kids deep inside, so don't restrain yourself.

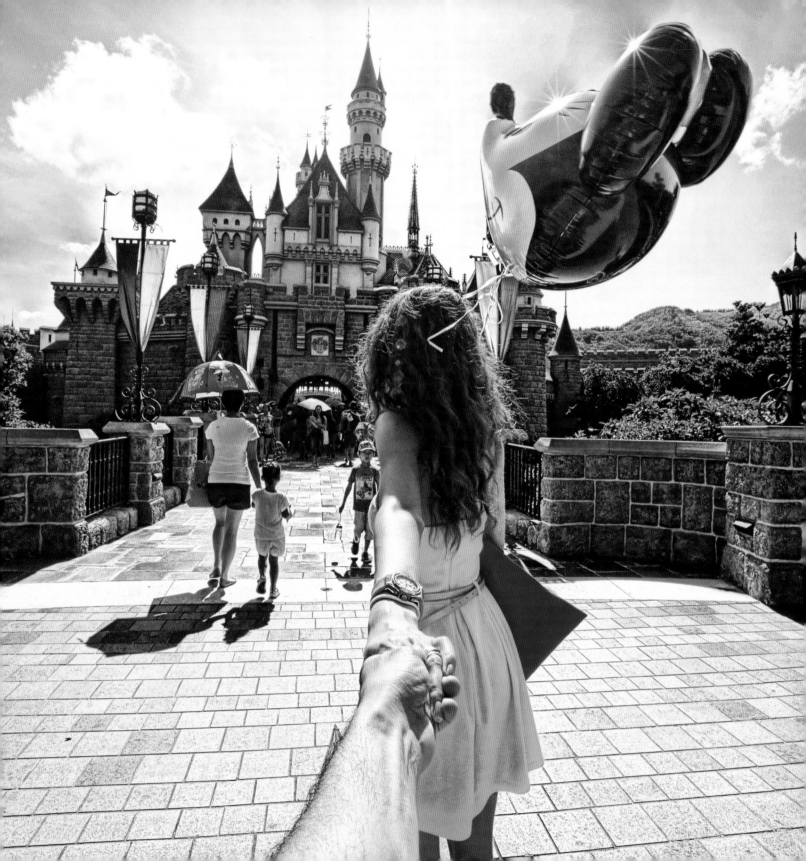

HONG KONG

Night

At night, every city on Earth changes and exposes a magical atmosphere—especially Hong Kong. We were out half of the night!

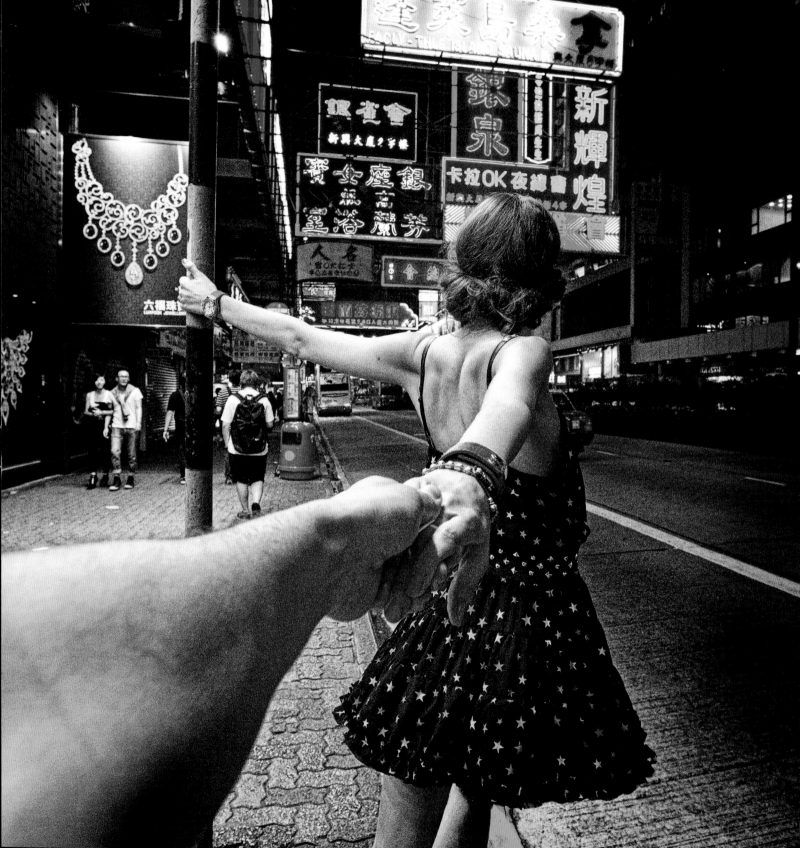

CHINA
HONG KONG

Hong Kong Island

Hundreds of people run past you every day and each one has his own thoughts, things to do, and directions. We see each other for the first and last time in our lives. A rushed and cold-hearted city.

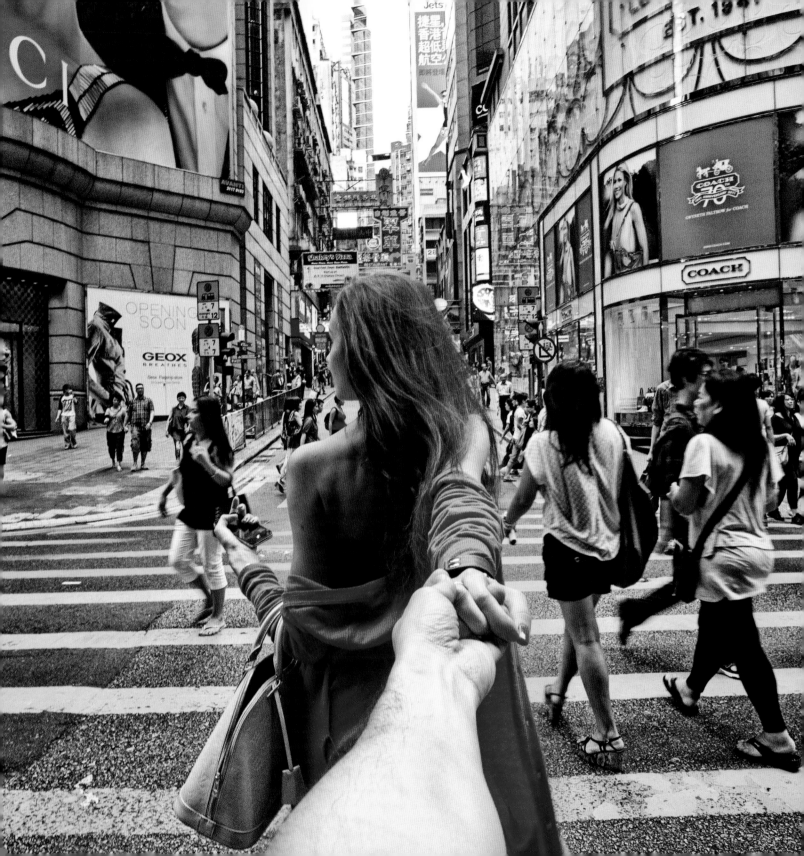

CHINA
HONG KONG

Ten Thousand Buddhas

When you are going up, you will see an incredible number of Buddhas on your way. I really wanted to look each one in its face, as every one is unique and inimitable. Ten thousand reincarnations.

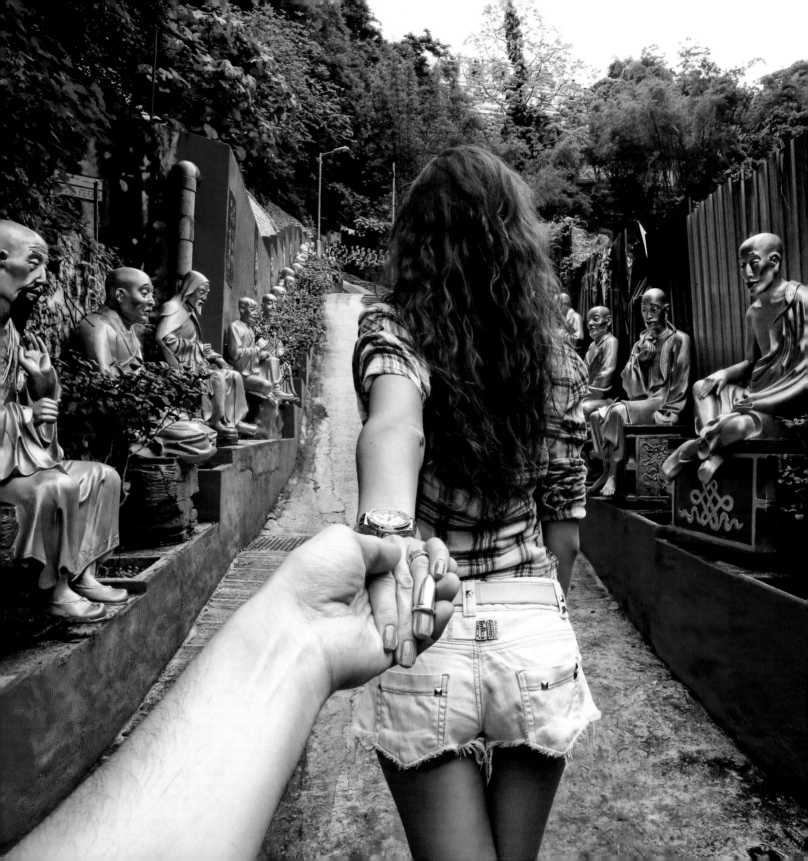

HONG KONG

Ten Thousand Buddhas Monastery

The monastery of ten thousand Buddhas—the Buddhist monastery is situated in Sha Tin district of Hong Kong! Tourists are amazed by China's peacefulness and the number of Buddhas.

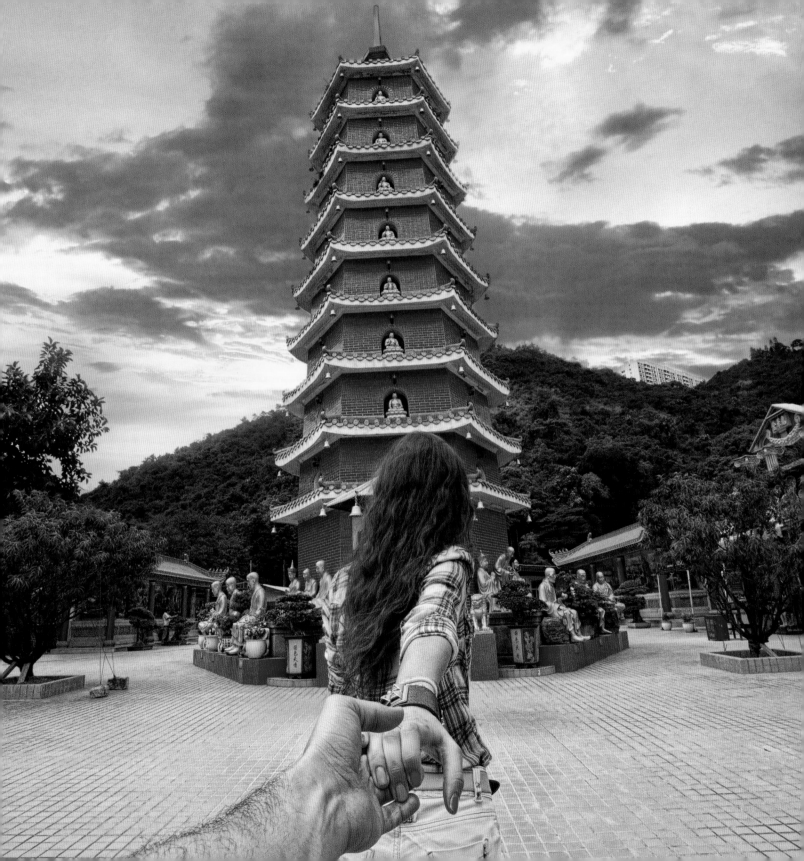

HONG KONG

Tai Lin Pai Park

An amazing wild park trapped in the circle of a manufacturing zone–a truly unique combination. Mysterious Asian beauty.

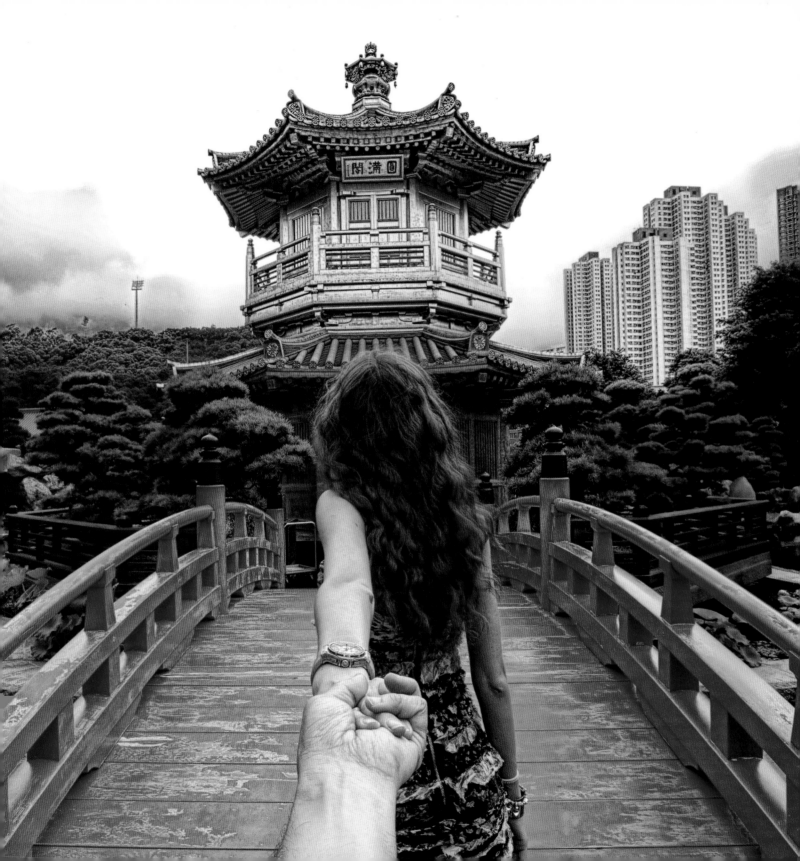

INDONESIA
BALI

Sekumpul Waterfall

The most beautiful and highest waterfall on Bali is the Sekumpul Waterfall. The nature of this island with a soul is amazing! There are around twenty waterfalls open for tourists on Bali, but to get there you have to make some effort.

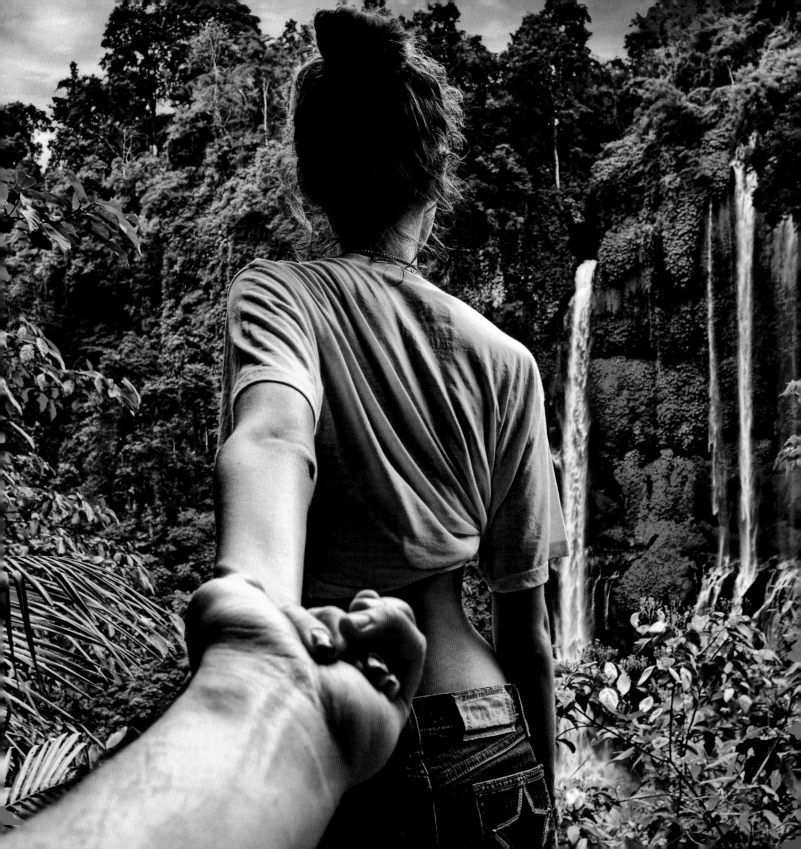

INDONESIA
BALI

Tegallalang Rice Terraces

Tegallalang rice terraces were formed by a river. The fields are so intricately carved, they look like they were made by some craftsman. There are many rice fields in various countries, but the Balinese have created a real masterpiece. They use every single piece of land! Nowadays, there are fewer and fewer fields due to incredible tourist fame and global construction development on Bali. During the last year, the stream of tourists has increased from 8,000 to 20,000! The fields are facing a severe threat.

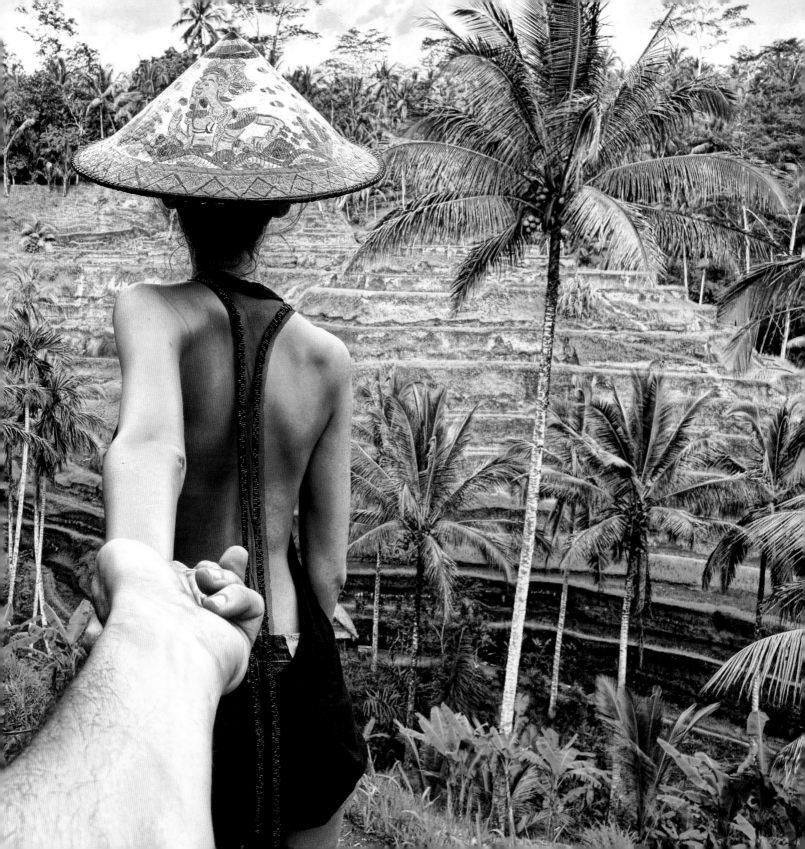

INDONESIA
BALI

School

There are many international (expensive) and local (cheap) schools on Bali; many foreigners living here send their children to catholic schools. When we arrived at the village next to Seminyak, many local school-aged kids stood next to a century-old tree—they were afraid of us and sang some funny songs.

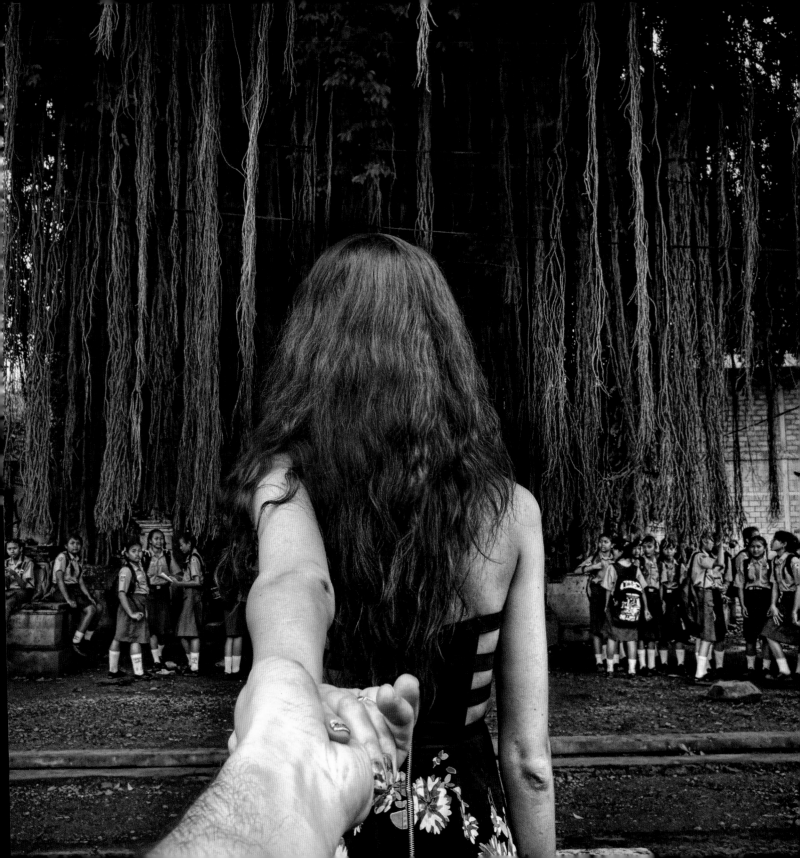

INDONESIA
BALI

Pura Ulun Danu Bratan

The Ulun Danu Temple–the main water temple of the island–is of such great sacral significance for the Balinese that its picture is printed on the fifty thousand rupees banknote. Many animals can be found on the temple grounds, like this python. There were so many people around the snake owner and I was so nervous that it would clutch my neck!!!

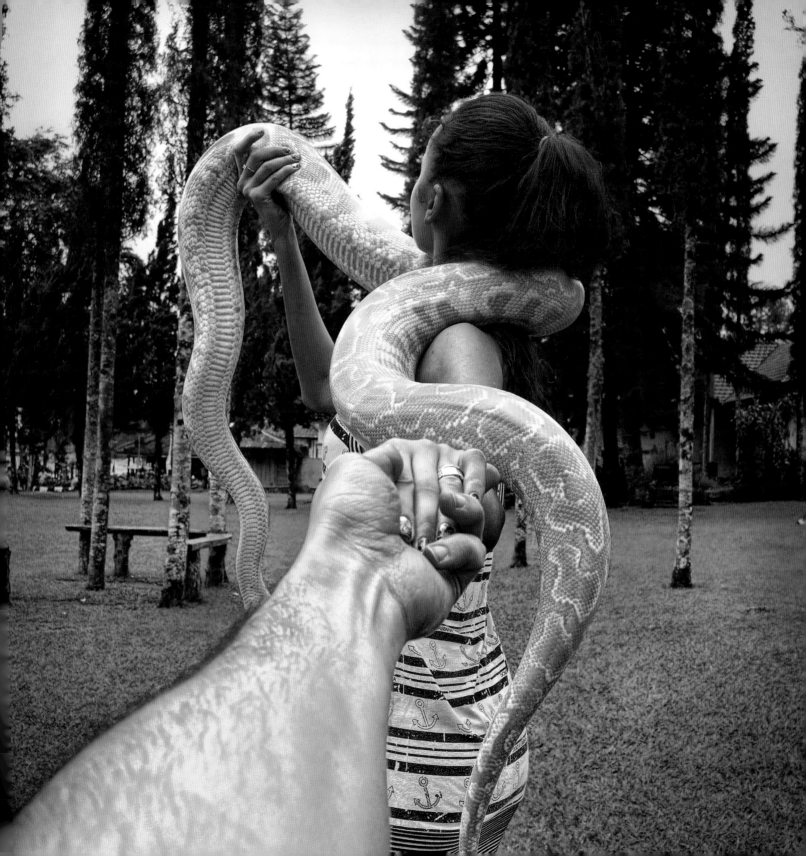

SINGAPORE

Marina Bay Sands Hotel

One of the most famous swimming pools in the world is located at the hotel rooftop-floor 70—at the height of 656 feet (200 meters). When you are there you can't believe it's real, and seeing the hotel from the ground makes the picture seem imaginary. So we decided to go a bit wild and took a photo with a duck floaty.

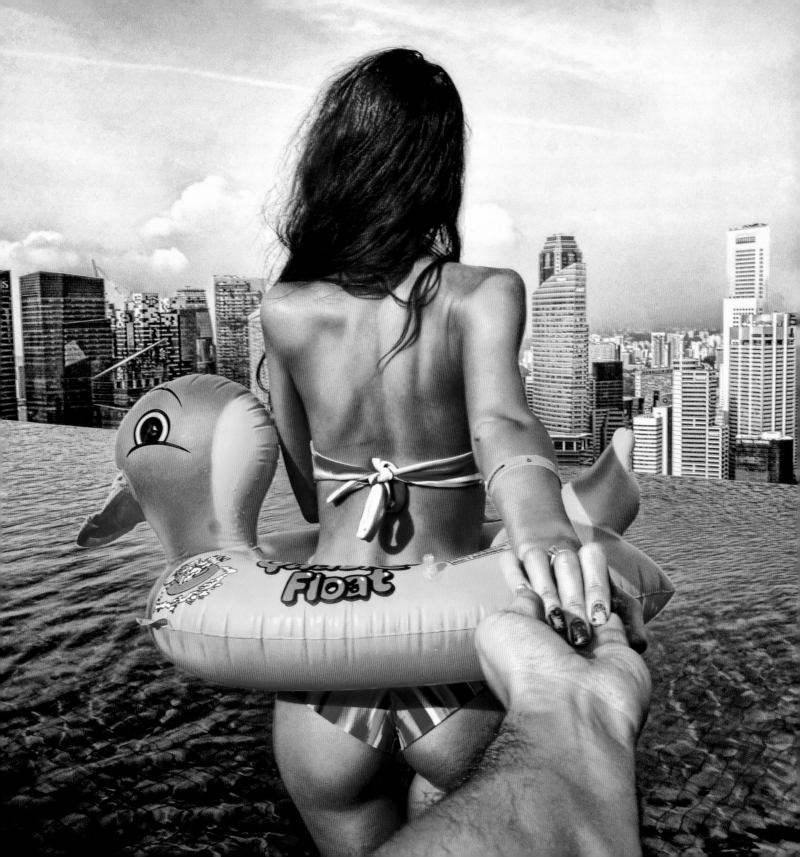

SINGAPORE

Universal Studio Park

Here we're in the grips of one of the silver screen's most famous monsters, Frankenstein. We could not leave such a larger-than-life hero unnoticed.

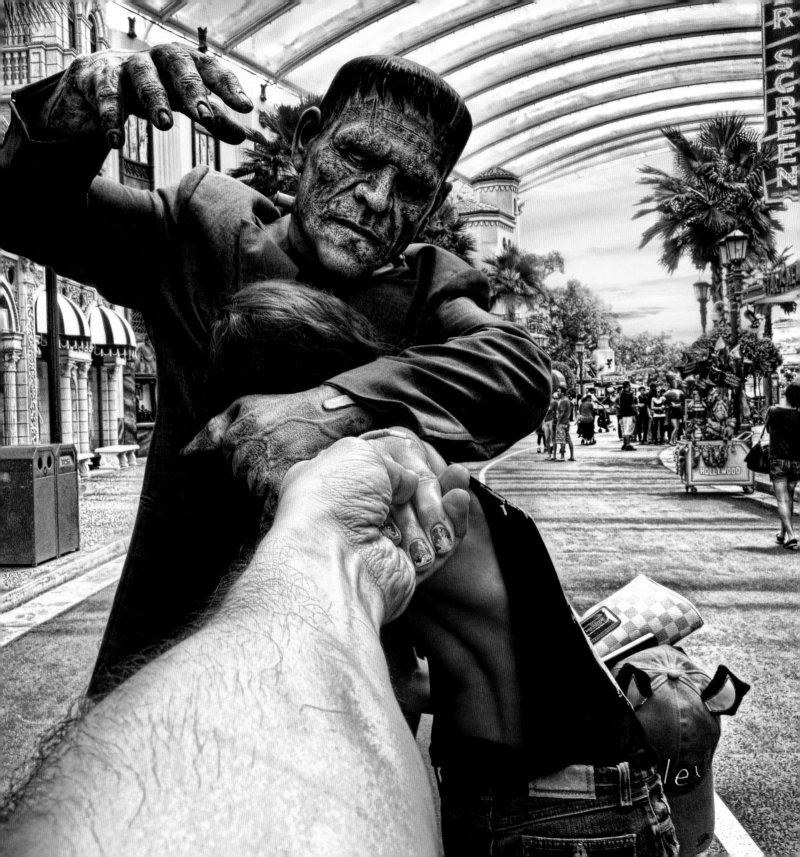

SINGAPORE

Universal Studio,
The Egyptian Sector

The Egyptian history dates back to centuries BC, and the grandeur and culture of Ancient Egypt are so impressive with their mysterious and noble atmosphere. In the background, we can see Anubis–the deity of Ancient Egypt with the head of a jackal and human body: he is the one who takes the dead to the afterlife.

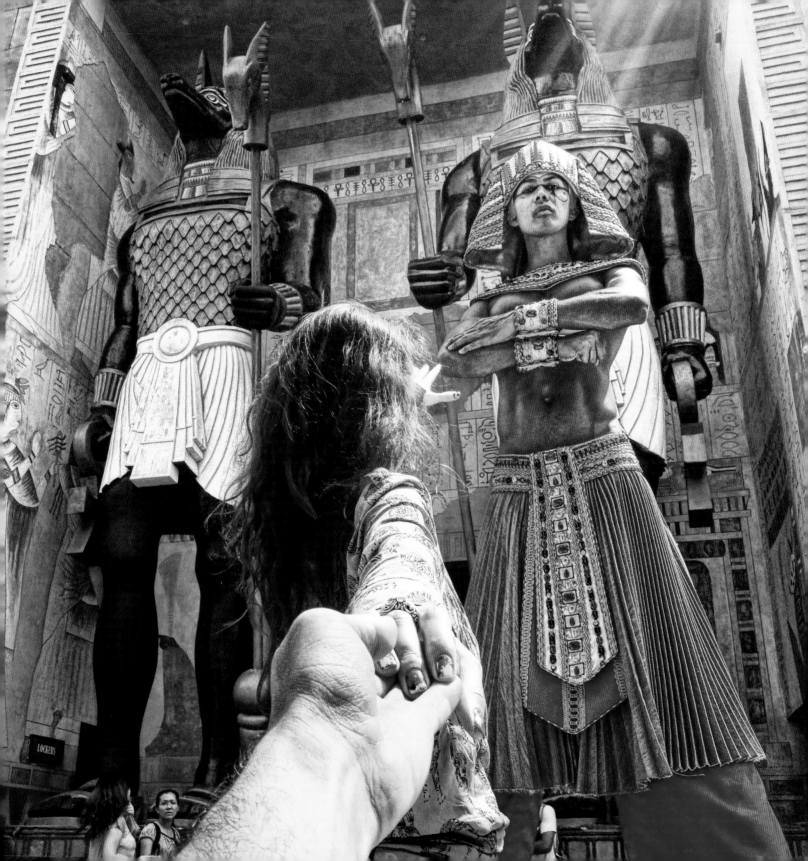